expressive oil painting

GEORGE ALLEN DURKEE

an Open Air Approach
to Creative Landscapes

NORTH LIGHT BOOKS

CINCINNATI, OHIO

www.artistsnetwork.com

EARTH COLORS

A second way to mix grays is by using earth colors, like Yellow Ochre, Raw Sienna, Burnt Sienna, Terra Rosa, Venetian Red, Burnt Umber, etc. These pigments are already grayed the way they come out of the tubes. When you add one of them to a color of high intensity, you get a color that is grayed. Keep in mind, however, that each of them is also a particular hue. Burnt Umber is a red, Burnt Sienna is an orange, Raw Sienna is a yellow and so on. Adding a bit of earth color, say Burnt Umber, to pure Cadmium Red will result in a grayed red. Add Raw Sienna or Yellow Ochre to any blue and you'll get a gray-green.

Using earth colors to alter other pigments without regard for their relationship to primary lines can result in dull, lifeless paintings. First, become proficient with the six-color palette (see page 47). Later on, when you do add earth colors, keep track of how they relate to the color wheel in the same way you do with other pigments.

AERIAL PERSPECTIVE

With distance, contrasts are lessened. Dark values especially become lighter, and lights become slightly darker. Also, colors usually become cooler and less intense with distance. This is because the air itself is composed of layers of moisture and dust particles through which we look. Spend time in nature looking for the subtle effects of atmospheric haze.

Other fine North Light books are available from your local bookstore, art
supply store, online supplier, or visit our website at www.fwmedia.com.

13 12 11 10 09 5 4 3 2 1

DISTRIBUTED IN CANADA BY FRASER DIRECT

100 Armstrong Avenue

Georgetown, ON, Canada L7G 5S4

Tel: (905) 877-4411

DISTRIBUTED IN THE U.K. AND EUROPE BY DAVID & CHARLES

Brunel House, Newton Abbot, Devon, TQ12 4PU, England

Tel: (+44) 1626 323200, Fax: (+44) 1626 323319

Email: postmaster@davidandcharles.co.uk

DISTRIBUTED IN AUSTRALIA BY CAPRICORN LINK

P.O. Box 704, S. Windsor NSW, 2756 Australia

Tel: (02) 4577-3555

Library of Congress Cataloging in Publication Data

Durkee, George Allen.

 Expressive oil painting : an open air approach to creative landscapes /
George Allen Durkee. -- 1st ed.

 p. cm.

 Includes index.

 ISBN 978-1-60061-151-3 (pbk. : alk. paper)

1. Landscape painting--Technique. 2. Plein air painting--Technique.

I. Title. II. Title: Open air approach to creative landscapes.

 ND1342.D88 2009

 751.45'436--dc22 2009014678

ABOUT THE AUTHOR

When George Allen Durkee began painting in 1965, there were no art schools
nearby, so he enrolled in a correspondence course designed by some of the
great illustrators—Albert Dorne, Robert Fawcett and Norman Rockwell.
Coached by knowledgeable teachers, he worked a night job in order to
study and practice during daylight hours. Without the imposed structure
of a classroom schedule, he learned to work on his own. After completing the
course, George quit the night job, and with twelve days' worth of vacation
pay in his pocket he became a full-time painter. For the next few years, he
painted his way from town to town, selling art to passersby. Trading a painting
in San Francisco for a few hundred dollars, he moved in. Within six months,
his paintings appeared in a prominent gallery—between the work of Picasso
and Miró. Hundreds of George's cityscapes were dispersed worldwide. In
2001, ready for a quieter life, he moved to the foothills of the Sierra Nevada
in Northern California to paint landscapes. Durkee is a past contributor to *The
Artist's Magazine* and *American Artist*. A knowledgeable teacher, he prefers
to work one-on-one with a few select students. He and his artist wife, Sharon
Strong, are co-owners of an art gallery in Murphys, California.

Metric Conversion Chart

To Convert	To	Multiply By
Inches	Centimeters	2.54
Centimeters	Inches	0.4
Feet	Centimeters	30.5
Centimeters	Feet	0.03
Yards	Meters	0.9
Meters	Yards	1.1

EDITED BY **SARAH LAICHAS**
DESIGNED BY **JENNIFER HOFFMAN**
PRODUCTION COORDINATED BY **MATT WAGNER**

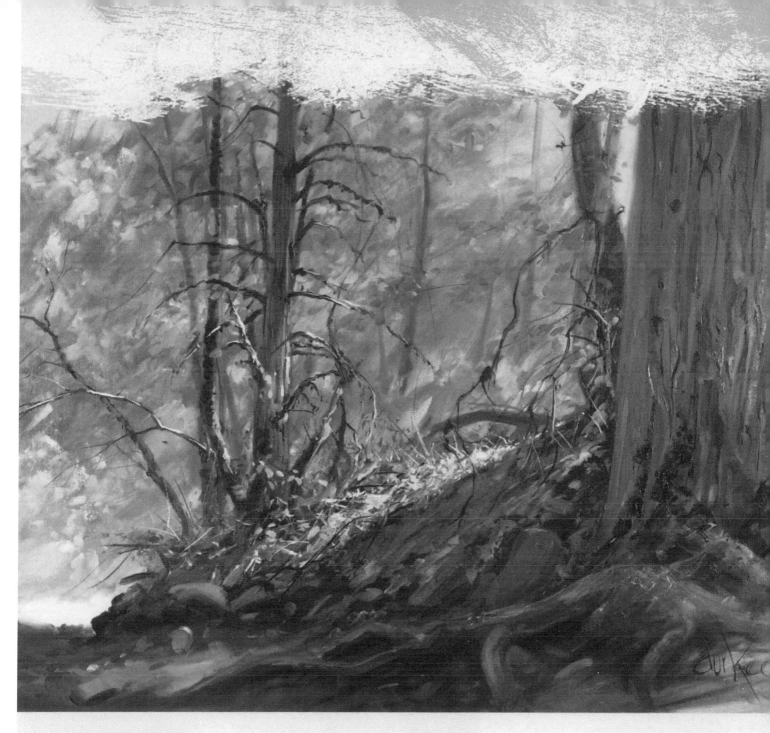

ACKNOWLEDGMENTS

Very special thanks to my ruthless North Light editor, Sarah Laichas—what a journey we have traveled together! Thank you Carolyn North, Nancy Roberts and Hélène Cartier for your thoughtful and reasoned feedback. Tom Cole, your nitpicking critiques have made this a more comprehensible book. Jane Boon Brown, you are better than you know. Buzz Eggleston, thank you for generously offering your expertise.

DEDICATION

For Sharon Strong: artist, psychologist, wife and best friend. If there's any poetry to this book, give Sharon the credit.

For my stepdaughters, Lisa Boyd and Christa Thompson. For Andrea Broglio, future star!

And in memory of my longtime friend and mentor, Vic Gioscia.

First Light oil on canvas | 24" × 30" (61cm × 76cm)

table of contents

Sonoma Mountain Road oil on canvas | 8" × 10" (20cm × 25cm)

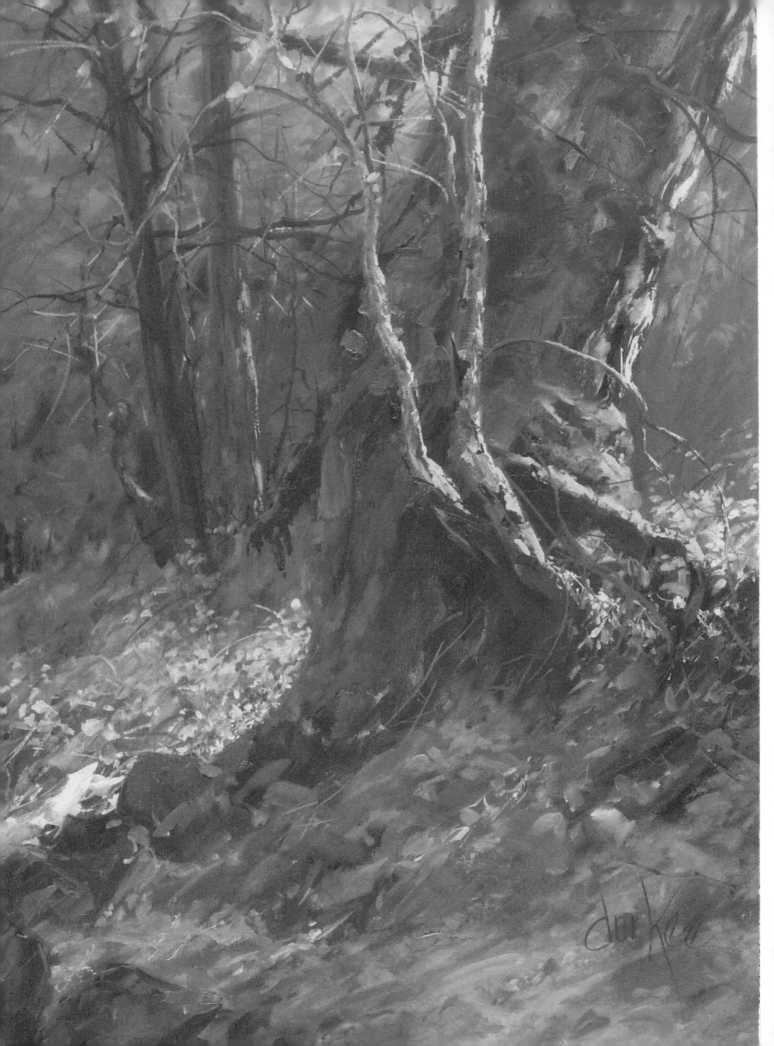

Introduction: A Short Chat

Knowing a range of oil painting techniques is like having a large vocabulary. But a collection of big words is not poetry. First, you need to know how to handle your paints and brushes, how to mix colors, how to draw. When you can replicate the physical appearance of a scene, your paintings will say, "This is what I see." The next level will be to discover and develop your own aesthetic so you can show how you feel about what you see. Learn the principles that are true for all painters and apply them in your own way; your work will reflect the world you live in and who you are within it.

If you need the concepts of oil painting explained in a straightforward way, you've chosen the right book. According to your learning style, work your way carefully from start to finish, or scan the entire text before returning to a section you want to study in greater depth. If you are an experienced painter, you may choose to go directly to the painting demonstrations in part two.

Do you grope for understanding while repeating the same formulas over and over? If your methods haven't produced the results you want, maybe it's time for a new direction. New ways of thinking and doing can feel disorienting, but that's OK. Discomfort will ease as the new ways take hold. To begin, take time to think honestly about the following four questions and write down your answers.

Where am I now as an artist?

What is emerging in my creative life?

Is anything blocking this emergence?

What do I need to become the painter I want to be?

Tuck your answers between these pages. Over time your answers may change. A realistic evaluation of where you are now and what you intend to accomplish will help you sustain the effort to reach your painting goals. Growing beyond what you know doesn't have to be hard work. Start where you are. "Every artist was first an amateur," observed Emerson. All of us, even the great ones, are climbing the same ladder.

"There are painters who transform the sun into a yellow spot, but there are others who with the help of their art and intelligence transform a yellow spot into the sun."

— Pablo Picasso

Big Tree oil on canvas | 30" × 24" (76cm × 61cm)

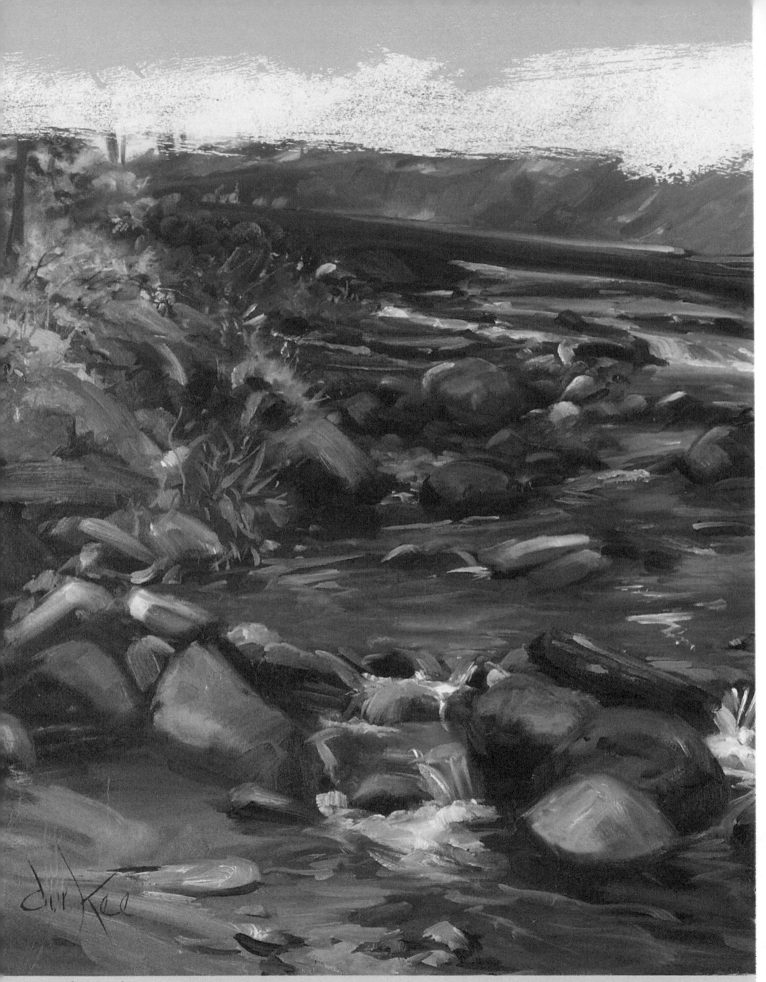

Walker Creek oil on canvas | 24" × 30" (61cm × 76cm)

part one: bedrock basics
Simplified Principles Every Painter Needs to Know

No one learns to paint by reading a book. You learn to paint by painting. As you read the following pages, make small studies to practice the principles you are learning. This is the fastest way to improve. Create studies on canvas, paper sealed with a coat of shellac or on the side of a cardboard box if that's all you have, but do them. Prove to yourself how much more quickly you can learn by painting instead of by simply reading. Be guided by curiosity. Experiment. Celebrate the joy of discovery as painting becomes demystified. If you feel resistance, apprehension or even fear during a practice session, just know that this is part of learning how to do things in a new and different way. When you feel frustrated or have that sinking, hopeless feeling and you want to stop so the feeling will go away, call it by name. Say, "I feel inadequate," or "I want to give up." Identify your feelings of resistance, breathe and keep on keeping on.

When I paint, brushstrokes rarely look exactly the way I imagine they will, paintings seldom turn out just the way I visualize them, and during the painting process, there is often a period when the work in progress looks nothing like the thing I'm painting. I gave up on many paintings before learning that chaos is simply one of the stages in bringing a painting together. So take a break, then put some more paint on the canvas and keep going.

To arrange time for learning, you may need to work around commitments that are not negotiable—like your job, school or family. The time left is yours for painting. Claim your time and use it efficiently. Starting can sometimes be the most difficult part of painting. If you paint regularly, a rhythm will develop to your work. Start because painting is what you do. If you are a weekend painter or experience interruptions due to the vicissitudes of life, it may be more difficult to get started. The day before you plan to paint, check your equipment. Make sure you have enough paint, rags, turpentine or mineral spirits and something to paint on. Get everything lined up and ready to go. Meditate on what you want to accomplish the following day. Then, when you wake up in the morning, you'll be ready to begin.

Chapter One
equipment and work habits

GOOD WORK HABITS HELP YOU TO FOCUS MORE INTENTLY ON THE PROCESS OF PAINTING. Claim a studio space just for painting, a regular place where you can keep your equipment set up and ready for work. Even if you do most of your painting outdoors, you'll still want to have an indoor workspace. A light source that is consistent is particularly important. Windows facing north are best and avoid direct sunlight. It is better to block off the windows altogether and use artificial light than to be frustrated by the glare and inconsistency of direct sunlight.

Whether painting indoors or outdoors, arrange your equipment and materials so everything you need is within easy reach while you work. Keep your paint tubes arranged in a logical sequence. Devise a holder for your brushes, and never lay a brush on the palette since the handle can become smeared with paint. Instead, clean it and return it to the brush holder. Always clean your palette when you are finished painting to keep the working surface smooth for easy mixing. You don't need fancy equipment to paint well; however, inefficient work habits are like speed bumps on the way to doing good work. You can still get there, but they slow you down. Every motion saved is another brushstroke on the canvas.

"Talent without discipline is like an octopus on roller skates. There's plenty of movement, but you never know if it's going to be forward, backwards, or sideways."

— H. Jackson Brown Jr.

THE MEDIUM OF THE MASTERS

The scent of oils is enough to get the painter's creative juices flowing.

Here, Try These! oil on canvas | 8" × 8" (20cm × 20cm)

Materials and Tools

Use the best quality materials you can afford. Experiment with different brands to find the ones you like best.

PIGMENTS

Student-grade pigments are okay to begin with, but graduate before long to higher quality colors. Economy paints substitute fillers for colored pigment and in the long run are less economical. Professional-grade paints are full strength. Their handling qualities have been adjusted for consistency from one color to another and they are a pleasure to use. I prefer Rembrandt oil colors except for Cadmium Scarlet and Terra Rosa, which are made by Winsor & Newton.

BRUSHES AND KNIVES

Care for your brushes conscientiously. Washing brushes with soap and water after each painting session will keep them clean and limber. Make sure they're completely dry before using again. I carry a second brush washer containing a roller and brush cleaner for pre-cleaning brushes in the field after I finish painting. This strong solvent removes most of the pigment and makes the soap and water cleaning much easier. However, it is not a substitute for soap and water. A quality brush well cared for will respond to your most sensitive touch, even after much use.

PIGMENTS

Cadmium Yellow Lemon, Cadmium Yellow Light, Cadmium Yellow Deep, Yellow Ochre Light, Raw Sienna, Transparent Oxide Red, Cadmium Scarlet, Cadmium Red Deep, Terra Rosa, Permanent Red Violet (or Alizarin Crimson), Ultramarine Blue Deep, Cobalt Blue Light, Prussian Blue, Viridian, and Titanium White (buy the large size)

BRUSHES AND KNIVES

Flat bristle, nos. 4, 6, 8, 10, 12; long bristle filberts, nos. 4, 10; long sable filberts, nos. 8, 14; small round sable, no. 6; rigger brush (long-haired sable), no. 6; knife with straight blade for mixing paint on palette; knives with offset blades for painting, 1-inch (3cm) and 3-inch (8cm)

WHAT TO PAINT ON

I prefer Fredrix Red Label medium-textured canvas. You can also use 1/8" (3mm) hardboard panels from your local building supply, primed with two coats of acrylic gesso brushed on in opposite directions. Non-absorbent, canvas-textured paper pads make economical experiments, as well.

MEDIUMS AND THINNERS

Mediums and thinners are two separate categories of liquids used to adjust the handling qualities of the paint. Thinners like turpentine or mineral spirits that have been mixed with tube paints evaporate quickly without altering the chemical composition of the paint. I use straight turpentine. Mediums, on the other hand, do alter chemical composition because they add oils or varnishes to the paint. However, they may help you achieve some textural qualities more easily than with thinners. Most are safe when used judiciously. You can mix a common medium by combining one part linseed oil, one part damar varnish and two or three parts turpentine or mineral spirits.

SKETCH PAD AND PENCILS

Your sketching equipment can be simple or elaborate. At a minimum carry a clipboard, a few sheets of computer paper and a 4B drawing pencil.

A FEW OF MY PREFERRED MATERIALS

Top: Various sizes of Fredrix Red Label medium-textured canvases.
Above: A sketch pad and an assortment of drawing materials.
Left: Linseed oil, turpentine, palette cup, damar varnish and mineral spirits. The palette cup clips onto the edge of the palette so you can easily dip a brush or knife to thin the paints.

Equipment for Outdoor Painting

Efficient portable painting equipment helps make for a more distraction-free painting experience. This is the setup I use. The French easel carries paints and brushes, and its legs can be adjusted to stand on uneven ground. If it's windy, pile a few rocks on it to keep it from blowing over. If there are no rocks handy, tie a rope around it and fasten the other end to a weight on the ground. An easel needn't be expensive or elaborate, but it does need to hold a canvas firmly and be adjustable to tip the canvas forward or backward to achieve the angle with the least amount of glare.

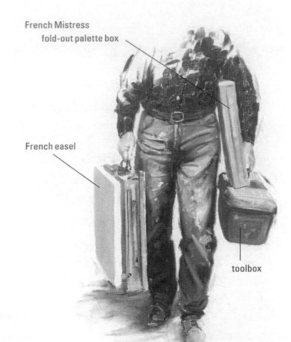

French Mistress fold-out palette box

French easel

toolbox

French easel

slide-out drawer

fold-out palette rests on slide-out drawer

THE PREPARED ARTIST

Use a French easel to carry your paints, brushes and canvas, and a toolbox for miscellaneous equipment.

FRENCH MISTRESS AND EASEL WITH A SLIDE-OUT DRAWER

A French easel folds into a compact box for easy carrying. The briefcase-shaped box at left is a French Mistress fold-out palette box. It rests on the slide-out drawer of the easel and provides a generous work space.

THE FRENCH EASEL SETUP

1 Front edge hinges down. Be sure the model you buy has this feature!
2 Palette is ⅛" (3mm) hardboard saturated with linseed oil.
3 Paint tubes, organized and within easy reach.
4 Folding pocket mirror for viewing your painting backward.
5 Cardboard behind the canvas to keep the light from showing through.
6 Canvas or ⅛" (3mm) hardboard panel primed with acrylic gesso.
7 Wear a hat to shade your eyes.
8 Small glass jar with clean turpentine for thinning paint.
9 Two cans bound together with 12 gauge copper wire to hold brushes and knives.
10 Brush washer contains turpentine or mineral spirits.
11 Terry cloth for drying brushes and wiping knives.

HOW TO SET UP A FRENCH EASEL

1 Extend one of the side legs to full length and tighten the nut.

2 Bring the leg into position and fasten it in place.

3 Extend the other side leg.

4 Unfold the second leg and fasten it in place.

5 Unfold the center leg.

6 Stand the easel upright and arrange your materials.

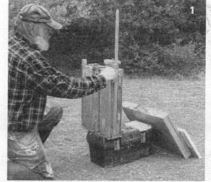

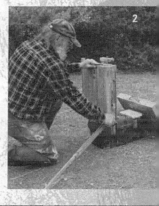

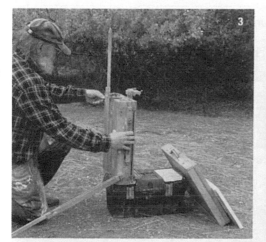

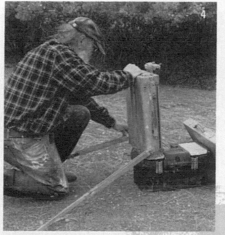

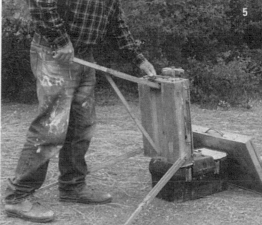

Closing Remarks

Art stores are full of unnecessary gadgets; only a few items are essential for oil painting. You do need a sturdy easel so your canvas doesn't move while you're working. Buy quality paints and use them generously. Have a standard place to put your brushes so you can easily reach the one you need. A conveniently positioned brush washer makes it easy to clean your brush before dipping into the next color. Organize your equipment and materials in an orderly way, and whenever you discover a way to make things more efficient, put it to use. Good work habits help you focus more intently on painting.

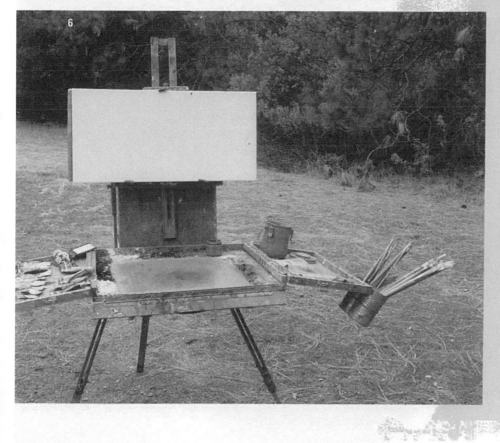

17

Chapter Two

seeing

Examine the painting on the facing page. Before you read on, take time to notice the house, trees, sky and green lawn. See how each of these picture elements is easily distinguishable from the others. Once you name these objects, they are filed away so you don't have to think about them anymore. If your brain didn't classify things in this way, you would go into overload while trying to process new incoming information. However, seeing the house as a "house" precludes you from experiencing it in a way that allows you to get this particular house onto your canvas.

ADVANCE BEYOND NAMING OBJECTS TO VISUALIZE THEM IN THE ARTIST'S SPECIALIZED WAY. Learn to divide a scene into easily understood parts so it can be reassembled on the canvas. To accomplish this, there are three main elements you need to look for in the subjects you draw or paint: shapes, values and edges.

EYESIGHT OR INSIGHT?

Artists see in a specific way and use a special vocabulary to talk about what they see. The three most important words in the artist's visual language? Shapes, values and edges.

"To see we must forget the name of the thing we are looking at."

—Claude Monet

Untitled Color Study oil on canvas | 9" × 12" (23cm × 30cm)

Shapes

An outline that represents an object or an area is called a *shape*. Because you have a flat surface to paint on, reduce objects in your scene to a series of flat shapes rather than simply seeing things with names like house, tree, sky and foreground. Visualizing the three-dimensional world as flat shapes is a learned mode of seeing.

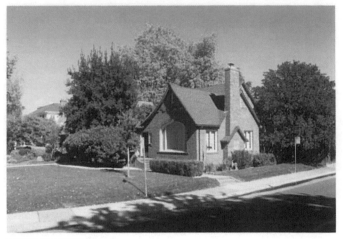

REFERENCE PHOTO

1 < **LOOK FOR THE LARGE SHAPE FIRST**
Here is the overall shape of the house. Always look for a large shape first. You may have more than one large shape.

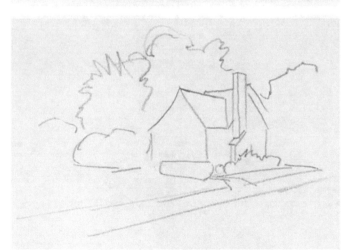

2 < **SUBDIVIDE**
Look for secondary shapes surrounding (and within) the main shape. It is much easier to place smaller shapes correctly if you have established the large, overall ones first.

3 > **DETAILS LAST**
Look for details only after you have found the flat shapes that symbolize your three-dimensional subject. "First the dog, then the fleas!"

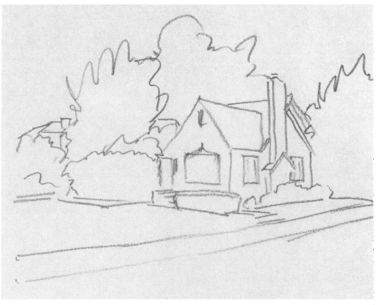

Values

Value means the lightness or darkness of shapes—black, white and all the variations between. Value is one of three basic properties of color. It is the attribute that is visible in a black-and-white photograph.

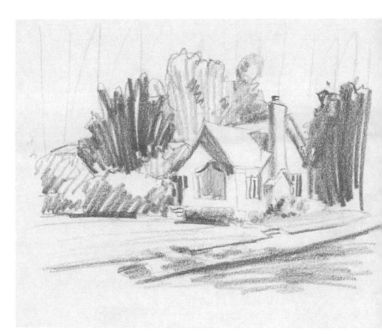

SEPARATE A SCENE'S SHAPES, LIGHT TO DARK
To represent a landscape authentically, first look for shapes, then look for how light or dark each shape is by comparing them to surrounding shapes.

EXPERIMENT WITH OTHER PATTERNS OF VALUE
The possibilities for rearranging values in a composition are endless, each depicting a different mood or weather condition.

Edges

Edges are the boundaries between shapes. If the transition from a house shape to a tree shape is abrupt, we call that a hard edge. If the transition from a tree shape to a sky shape is gradual, we say it's a soft edge. Rounded forms usually have softer edges, whereas squared-off forms have harder edges. Cast shadows generally have harder edges, which may become a little softer farther away from the object casting them. Distant shapes are often softer than near ones.

Beyond this, you can employ your artistic license in the use of edges. For example, save the hardest edges for the places where you want the greatest impact, and use softer edges in peripheral areas to de-emphasize them.

When you look at a painting, try to understand how the artist uses edges to convey roundness, to communicate distance and to focus attention on important areas of the painting.

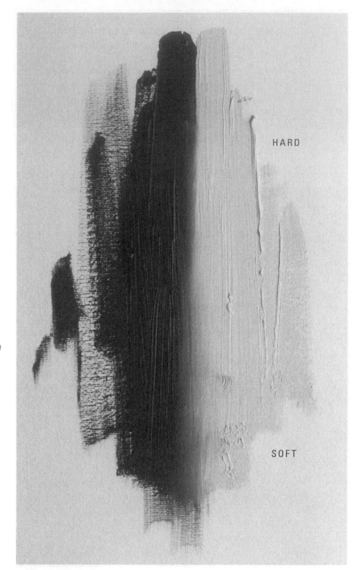

HARD

SOFT

HARD AND SOFT EDGES

1 Harder edges encourage the viewer to look here first.

2 Softer edges help to de-emphasize these areas.

FOR THAT PROFESSIONAL LOOK

Sensitive rendering of edges can make the difference between a good painting and a great one. If the things you paint look like cardboard cutouts, check the edges. But don't get carried away with softening everything; employ a variety of edges from soft to hard.

My Stuff
oil on hardboard panel
24" × 30" (61cm × 76cm)

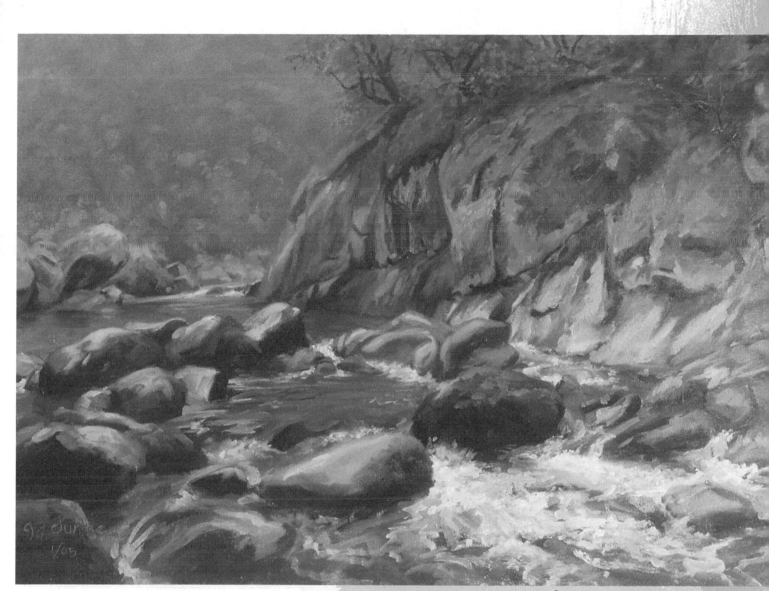

Gray Day at Big Rock
oil on hardboard panel
24" × 36" (61cm × 91cm)

EDGES HELP CONVEY MOOD

I painted this gray-day painting from under a bridge in the rain. Notice in particular the softness of the edges and how they become progressively softer with distance.

Closing Remarks

SHAPES are the parts the subject is composed of.

VALUES are what distinguish one shape from another.

EDGES are the places where shapes fit together.

These three elements of seeing are the bedrock of drawing and painting. When transferring three-dimensional objects onto a two-dimensional canvas, look for shapes, values and edges.

The following three chapters discuss basic ideas of drawing, color and composition. The closer you come to having these concepts automatically available, the more readily you will paint from intuition, like a violinist who simply feels the music while the music plays itself.

Chapter Three
drawing

TYPICALLY, PEOPLE SPEAK OF DRAWING AND PAINTING AS TWO SEPARATE THINGS. But just as a pencil deposits graphite or charcoal onto a paper surface, a brush deposits paint onto the surface of the canvas. Painting is simply drawing with a brush and introducing the additional elements of color and texture. To paint at an increasingly higher level, practice drawing often and trust your own personal vision.

The painting demonstrations to follow assume you have a level of competence in drawing. If your drawing ability needs improving, this chapter will show you some basics. There are numerous good books available on the subject of drawing, so rather than engaging in an extensive treatise, these few ideas will pique your curiosity and give you some directions to explore.

SEE FIRST, THEN DRAW
This sketch was done in preparation for a large painting. Spirited drawing, whether with pencil or brush, is a marriage of careful observation and trusting your hand to put down what you have seen.

"You can't do sketches enough.
Sketch everything and keep your curiosity fresh."
— John Singer Sargent

Thelma's Place 4B graphite pencil on sketch paper | 12" × 16" (30cm × 41cm)

Form

Drawing three-dimensional forms involves not only a degree of physical coordination, but also a level of mental activity. It's not necessary to struggle in order to draw well, but it does require focused effort and practice.

If you can see shapes and then transfer them onto your flat, two-dimensional surface, you can draw. But there's more. The accumulation of shapes conveys the illusion of volume existing in space. We think shape, and we feel volume. Whether drawing a tree, a grove of trees, a winding country road or a view of Main Street, begin by looking for large overall shapes. Then, subdivide these shapes into smaller compo-nents. As you do this, try to feel the depth and volume the objects occupy in space. Each object has a front, sides and back. Imagine grasping one object in your hands. Run your hands around it from the front to the backside. Get a visceral sense of its bulk and mass.

THE FOUR BASIC FORMS

Although in nature there is an infinite variety of volumes existing in space, all of them can be reduced to four basic forms or combinations of these forms—cube, cone, sphere and cylinder.

PRACTICE OFTEN

During my early training, I drew these basic forms many hundreds of times. For models, I found kitchen items and objects from around the house. Don't use photographs when doing these exercises. Draw from real, solid objects that you can grasp in your hands—and your heart and imagination. Always draw and paint shapes, but feel form and volume. Whether drawing with pencil or brush, broadly place your strokes using your entire arm.

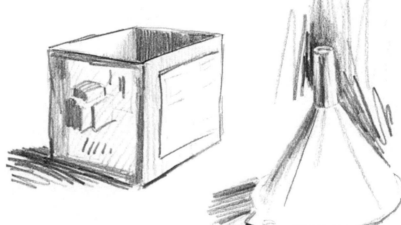

Drawing Practice Tips

When practicing drawing, visualize the basic forms in the subject; they are the components that make up the painting. Take a few practice swings the way a golfer does. Imagine where the line or brushstroke will go, then put it there. When working with a pencil, train your arm to move in the same way it does when you paint. Draw in the same size and scale as when painting. Practice, and practice some more.

The Picture Area

The *picture area* is a rectangular section of nature that you choose to make into a painting. It has the same proportions as your canvas. You may be excited to get started painting, but take time to select a pleasing composition. Move around and try different vantage points.

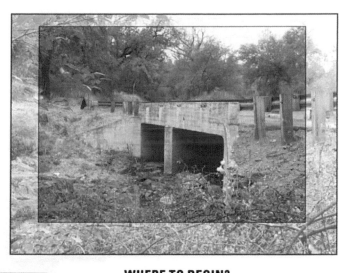

WHERE TO BEGIN?

When painting a landscape from life, select a section of nature to re-create on the canvas.

IMAGINE A RECTANGLE

Try framing a potential picture area with your hands. Make the frame larger or smaller.

A HANDY AID

Another way would be to cut a window to look through out of cardstock. The window needs to have the same proportions as the canvas.

The Reference Object

This procedure looks a lot more complicated than it actually is. It only takes a few minutes to accomplish. To begin the painting, place one object on the canvas. This is the *reference object*. After it is accurately drawn, its units of measurement can be used to gauge succeeding shapes. In order to get the reference object the right size relative to the entire picture area and to put it in the right place, work alternately with two different areas at the same time. The first is the area of nature you're about to paint. The second is the corresponding area of the canvas. Because the real-life subject and the canvas are not the same size, first gauge distances on the subject, and then transpose proportionate distances to the canvas.

There are other ways to get a painting to fit together. It's okay to use a modified version of this approach or even ignore it altogether, and simply intuit your way into a painting.

1 > MEASURE THE SUBJECT
Imagine boundary lines surrounding the area to be included in the painting as described on page 27. This is the picture area. The reference object for this demonstration is an easy-to-read section of the bridge seen from an angle. (If the reference object you choose has an odd shape as this one does, imagine it framed in its own rectangle.) Next, with your thumb on a brush handle, measure the distance from the edge of the picture area to the edge of the reference object. Then, count the number of times this measurement fits across the picture area. In this case, the answer is three and a little less than one half.

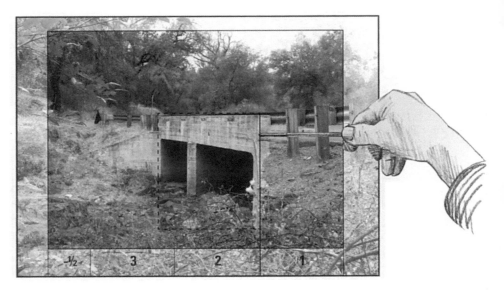

2 > MARK THE CANVAS
Determine the corresponding measurement on your canvas. This will require some trial and error because the canvas is a different size than the real-life subject. With your thumb on the brush handle, count across the canvas to find the proportionate measurement. You may be lucky enough to get it right on the first try, but if not, simply readjust your thumb on the brush handle and count across the canvas again. Do this as many times as necessary until you count the same number of measuring units on the canvas as you counted on the real-life subject in step 1. When you get it right, mark it on the canvas. Use care with this process because later measurements in the painting depend on an accurate reference object.

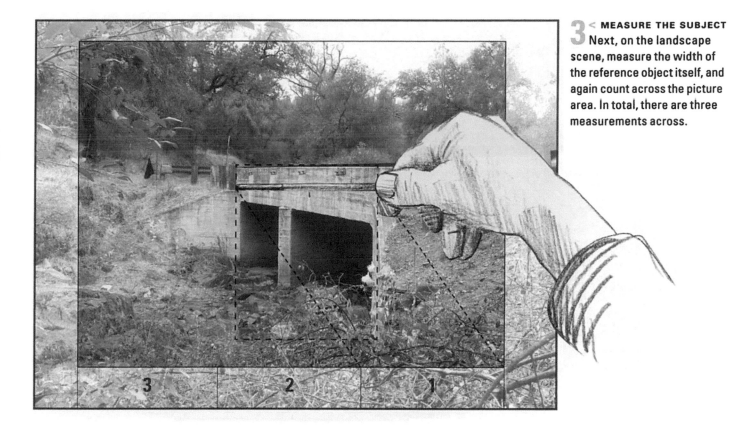

3 < **MEASURE THE SUBJECT**
Next, on the landscape scene, measure the width of the reference object itself, and again count across the picture area. In total, there are three measurements across.

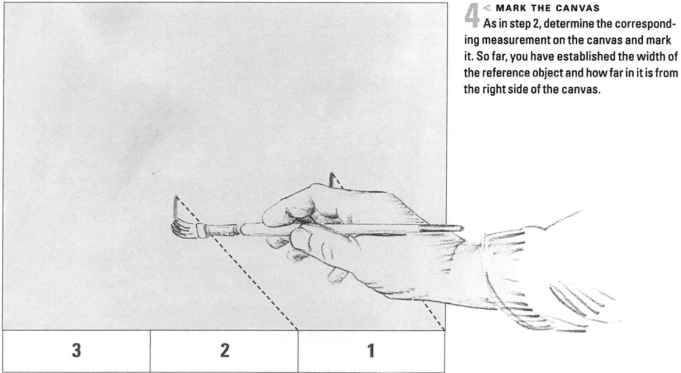

4 < **MARK THE CANVAS**
As in step 2, determine the corresponding measurement on the canvas and mark it. So far, you have established the width of the reference object and how far in it is from the right side of the canvas.

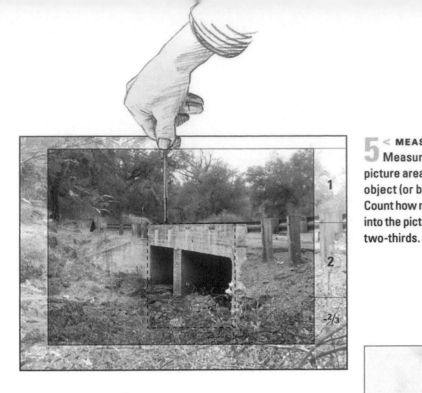

5 < MEASURE THE SUBJECT

Measure from the top of the selected picture area down to the top of the reference object (or bottom up if that works better). Count how many times this measuring unit fits into the picture area. Two and a little less than two-thirds.

6 > MARK THE CANVAS

Using the same procedure as in steps 2 and 4, find the corresponding distance on the canvas and mark it.

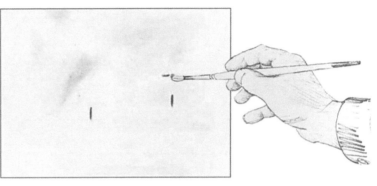

7 < MEASURE THE SUBJECT

At this point you can find how high the bridge is by simply comparing height to width.

8 ∨ MARK THE CANVAS

Measure and make the final mark for the corresponding height of the reference object. Now you know where the reference object goes and how big it is on the canvas.

9 > IT'S DOWNHILL FROM HERE

Begin drawing the reference object over the markings. Continue to use your thumb on the brush handle to gauge the relative sizes of the subdivided parts.

10 ^ A SOLID BEGINNING

In a few minutes, you have established units of measurement on the canvas that you know are correct. Now you can confidently relate the rest of the composition to the part you've already completed. By taking comparative measurements, everything else in the composition will fit into place.

Perspective

Drawing in perspective is a combination of understanding, careful observation and practice. Perspective is really an optical illusion. The theory of *perspective* is simply a way of explaining the way things look rather than the way they actually are. Understand this optical distortion and draw what you see. I'll help you with the basic overview of how perspective works, the basic theory and how to put the theory into practice.

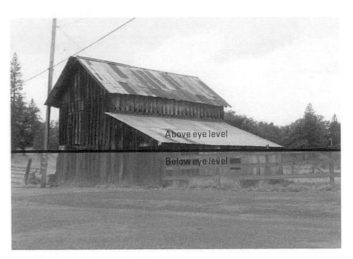

Above eye level

Below eye level

1 ∧ FIRST, THE EYE LEVEL
It may be helpful to think of the world as filled with water up to the level of your eyes. You look up at everything above the water level, and down at everything below.

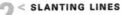

2 < SLANTING LINES
Receding horizontal lines appear not horizontal at all, but instead seem to slant. These lines, which in reality are parallel to the horizontal eye level, slant to varying degrees according to how far they are above or below the level of your eyes. Extended far enough beyond the shapes they define, they will converge with the eye level. These convergences are called *vanishing points*. It is not necessary to draw actual lines extending beyond the objects you depict and all the way to vanishing points. However, you do need to visualize them.

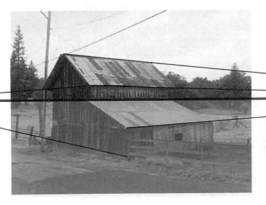

3 < THE SLANT CHANGES
This photograph was taken from a higher eye level. Compare the perspective lines to the ones in step 2. See how the slant of the lines has changed. Now they correspond to the new eye level. When you raise or lower your eye level, vanishing points and perspective lines will change accordingly. This means if you visualize painting while standing and then sit down to paint, the look of things will have altered.

More on Perspective

THE PIVOT POINT

Think of the vanishing point as the *pivot point*. Perspective lines swing from this point whenever you change your point of view. Study this page and then go outdoors and find some actual perspective lines on the side of your house or apartment. Trace a few perspective lines to their common vanishing point. Squat down and stand up a few times, move sideways a few steps one way and then another. As you move, watch the vanishing point move while the perspective lines pivot from this point of convergence, changing their angle. This exercise will help you understand the dynamic, three-dimensional quality of linear perspective.

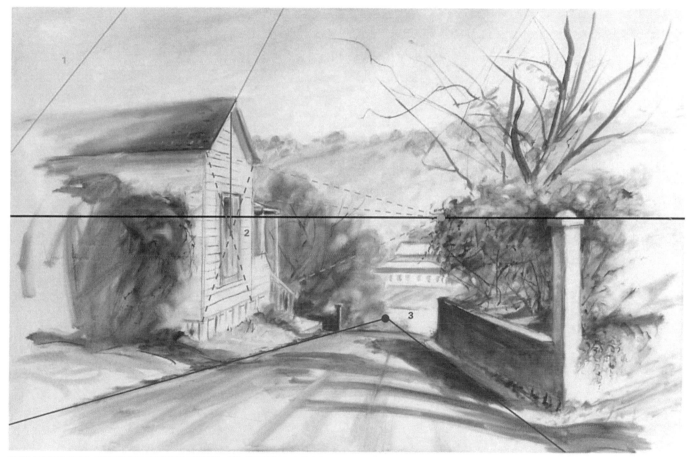

THE DYNAMIC SYSTEM OF EYE LEVEL, SLANTING LINES AND VANISHING POINT

In the actual subject, the blue dotted lines are parallel to the eye level even though they appear to slant. These lines, along with the eye level and vanishing point, form a dynamic system. Think of the vanishing point as the pivot point. The blue dotted lines will swing from the pivot point according to the angle of your view. Move sideways and the pivot point will slide sideways along with you. Move up or down and the pivot point also moves up or down. Whenever you move—whether up, down or sideways—the pivot point moves. When the pivot point moves, the blue dotted lines change to a different angle.

1 Edges of the roof slope uphill and are independent of the eye level.

2 To find the peak of the roof, draw an X on the front of the house. Extend a vertical line upward.

3 Edges of the road slope downhill and are therefore independent of the eye level. To locate the vanishing point for the road, follow both receding edges of the road into the distance until they converge.

Drawing Perspective Lines

Before beginning a drawing or painting, spend a few minutes studying the scene in front of you. Observe which perspective lines slant up and which ones slant down. Although we talk about eye level, slanting lines and vanishing points as separate entities, all three are parts of one coordinated whole. First locate eye level and vanishing points, then draw the slanting lines. After you have drawn a series of perspective lines, verify the angle of the lines by comparing them to vanishing points and eye level. Visualizing perspective lines as parts of a coordinated system, make corrections as needed. The method you use is less important than the result you end up with. Drawing in perspective is, more than anything else, the result of understanding.

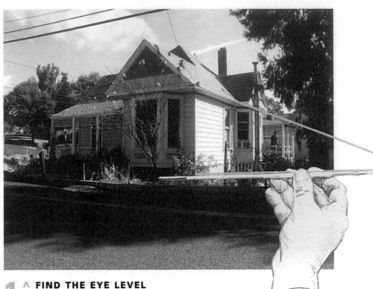

1 ^ FIND THE EYE LEVEL
Choose two receding perspective lines, both reaching toward the same vanishing point, one slanting downward and one upward as in the illustration above. Hold your brush handle parallel to one of these lines and follow it out beyond the object you are going to draw. Do the same with the other perspective line. These two lines will intersect with each other at the vanishing point, and this will show you where the eye level is located.

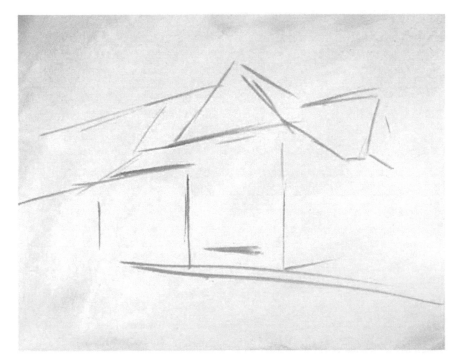

2 < TRACE IT AND PLACE IT
To draw the perspective lines on your canvas, study the subject and gauge the slant of a line as it heads toward a vanishing point by tracing it in the air with your brush. Swing back and forth along the line like a golfer taking practice swings before hitting the ball.

On the canvas, duplicate the angle of this line as accurately as you can. Move on. Do the same with the next line. As perspective lines accumulate on the canvas, you may need to make adjustments in the drawing. Coordinate perspective lines so they work together, aiming harmoniously toward their common vanishing points.

Exaggerated Perspective

The good news is that perspective is one of the aspects of painting where not quite perfect can be better than absolutely perfect.

Perspective drawing doesn't have to be rigid and mechanistic. A drawing or painting that loosely follows the principles of perspective will often be the most pleasing. With practice, your paintings will feel relaxed, yet accurate. Now and then, you can violate the rules altogether. Once you become skilled, you can exaggerate proportions of forms and still convey the illusion of depth and volume.

Find Perspective Mistakes

Periodically, look at your work backward in a pocket mirror to get a fresh look at what you've done. This will reveal distortions you might otherwise not notice.

ACCURATE DRAWING

In this sketch proportions remain true to the real-life subject. It's a personal choice whether to draw and paint photographically or deviate from what you actually see. Accidental inaccuracies can sometimes make your work more interesting.

DISTORTION ADDS CHARACTER

You're the artist. Go ahead and play, have fun. It's just paint. I wiped the canvas off and restarted twice before getting this result. The tree on the left was originally too dark. Wiping with a dry rag made the whole composition come alive.

Thumbnail Sketches

Before painting, it is best to spend time contemplating how to arrange objects on your canvas. But don't overplan and try to control everything in advance. It is better to strike a balance between knowing your destination and allowing the way to be revealed as you go.

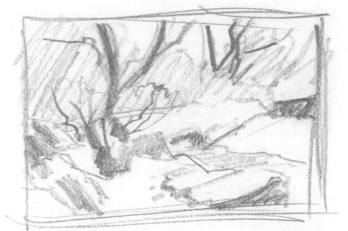

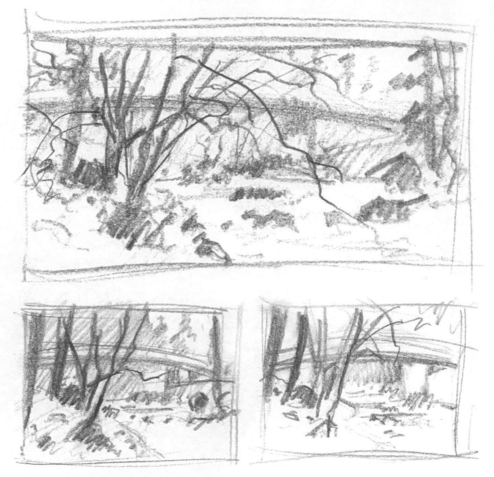

THE FIRST IDEA IS NOT ALWAYS THE BEST

Drawing thumbnail sketches with a pencil and sketchbook is a good way to think about the design of a painting before you set up your easel. A few sketches of your subject can save you the anguish of working for hours (or days) on a painting only to finally acknowledge that it was poorly conceived from the start. Sketch your subject from different points of view. Move closer, and farther away. When you hit on an arrangement of elements that works well within the picture area, do a few more sketches to find an even better idea. Search for a second right answer. Here are some thumbnail drawings from my sketchbook.

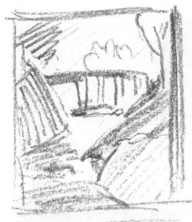

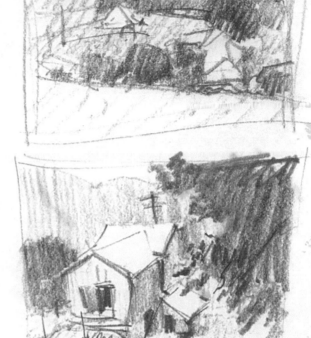
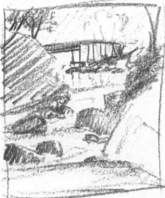

Closing Remarks

Slow down, look deeply and measure carefully. Go beyond drawing in a mechanical way. Test the boundaries of representational drawing. Strive for believably solid forms expressed with the gesture that is uniquely your own.

Some painters attempt to bypass the challenge of drawing by projecting images onto their canvas. This fools only the naïve viewer. If you do this, think of it as merely a stage in your development. Remember, expressive painting is drawing with a brush. A line traced along the edge of an object by mechanical means has no soul. A line freely drawn from the heart, through the human hand, communicates your unique personality. If you aspire to a higher level of painting, aspire to a higher level of drawing. Make the commitment to do at least one drawing a day for the next year. You'll be delighted by the increased sensitivity of your paintings.

With study, the principles of drawing can be easily learned. The more you practice them, the more they become a part of you. Not many people have the freedom to draw and paint all day, every day. However, nearly everyone has blocks of time too short for a painting session but long enough to practice drawing with a pencil and a sketchpad. Your ability to draw, whether with a pencil or a brush, will improve in direct proportion to the amount of time spent drawing.

Chapter Four

color

IT'S ONE THING TO GRASP COLOR THEORY ON AN INTELLECTUAL LEVEL. PRACTICAL APPLICATION IS ANOTHER THING ALTOGETHER. THIS TAKES TIME AND PRACTICE. If you were learning to play a piano, you would probably be awkward at first. You would have to think about which key to press with which finger. Later on you'd pay more attention to how hard to press each respective key. After a time, with all the information programmed into your brain, you would be able to sit down at the piano and play beautiful music, fluently and with feeling. The same goes for using color in your paintings. It may be difficult and even frustrating at first, but after awhile it will become second nature. Some of the following ideas are probably familiar to you, but review them anyhow. Learn this material well; you'll be glad you did.

Almost 150 years ago, a scientist named Hermann von Helmholtz studied perception. From his research into visual phenomena, he found that every color has three distinct properties. Today, his observations have profound implications for artists struggling to make sense out of the infinite range of color in nature. You'll reap huge rewards for the rest of your painting career by learning to think of color as hue, value and intensity.

WHAT IS "REAL"?
Exaggerated colors in this picture were inspired by the actual subject. Simply copying the colors you see may not communicate the vitality of your landscape. Train yourself to think in terms of color's three properties: hue, value and intensity.

"Color is so much a matter of direct and immediate perception that any discussion of theory needs to be accompanied by experiments with the colors themselves."

— Walter Sargent

Riverbank oil on canvas | 24" × 26" (61cm × 66cm)

Hue

Let's go back to third grade for just a moment. You may already be familiar with the *color wheel*. Because the wheel is foundational to color mixing, let's begin with a brief review that will give you a new context for using what you know.

Hue is the first basic property of color. It refers to the names of colors, like red or blue or yellow. Hue is independent of whether a color is light or dark or bright or dull. This is an important distinction. Imagine holding a pink book in one hand and a deep red book in the other. One is light, the other is dark; one is pale, the other is rich with color. The hue of each is red.

PRIMARY COLORS

All other hues are combinations of the three primary colors: yellow, red and blue. A desktop printer uses only three colors, yet can make all the colors in this book.

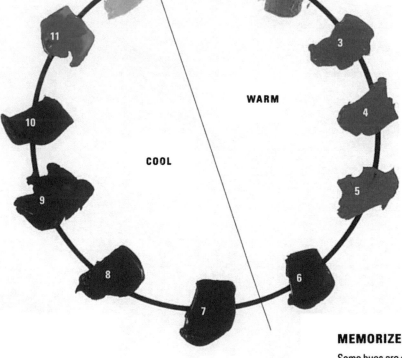

1	YELLOW
2	Yellow-Orange
3	Orange
4	Red-Orange
5	RED
6	Red-Violet
7	Violet
8	Blue-Violet
9	BLUE
10	Blue-Green
11	Green
12	Yellow-Green

MEMORIZE THESE HUES

Some hues are called warm and others are called cool because of the way we respond to them. If you haven't already done so, memorize the arrangement of hues on this color wheel. As you mix colors, you will work constantly with their relationships. Can you visualize this color wheel with your eyes closed?

Know Your Pigments

The names of pigments, like Burnt Umber, Prussian Blue and Cadmium Red Light, don't tell you the actual hues of these colors. So, to fix in your mind the hue of each pigment as it comes from the tube, get out your paints and make a chart like the one below. It will only take you an hour or so. When you mix colors, these are the ones you have as your starting point. Always know where your pigments are located on the color wheel.

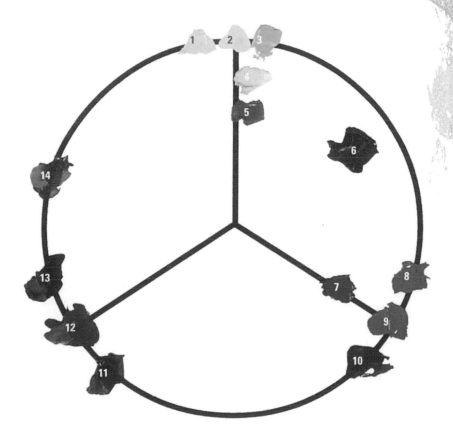

1 Cadmium Yellow Lemon
2 Cadmium Yellow Light
3 Cadmium Yellow Deep
4 Yellow Ochre Light
5 Raw Sienna
6 Transparent Oxide Red
7 Terra Rosa
8 Cadmium Scarlet
9 Cadmium Red Deep
10 Permanent Red Violet
11 Ultramarine Blue Deep
12 Cobalt Blue Light
13 Prussian Blue
14 Viridian

MY PIGMENTS

This chart shows where each of the pigments I use is located on the color wheel. When you make your chart, use the colors you have in your own paint box. Make a circle and place each color in position on the wheel. (If you find the darker pigments hard to read, add a little white to them so the hue is easier to see.)

Value

The second basic property of color is *value*. We briefly discussed value as we were learning how artists see (page 21). If you have a light green and a dark green on your palette, the "green" part of these colors is hue. The light and dark part is value.

HOW TO READ VALUES

The range of values in nature is infinitely greater than the range of light to dark that you have available to paint with. And yet, we've all seen paintings that are magnificent depictions of nature. How is that done?

Instead of duplicating the values in nature—which is impossible—paint the relationships of those values. If the tree is darker than the sky, paint it darker. If the sky is lighter than the shadow side of the hill, paint it lighter than the hill.

Ask, *Where is the darkest dark in my subject?* Next, *Where is the lightest light?* Then ask something like, *How much lighter than the darkest dark is that foliage behind the rock?* And, *Is the shadow side of the foliage lighter or darker than the hill?* And so on. Do this before starting your painting. Once you understand the value relationships in your subject, it's a simple matter of transferring the same relationships to the shapes in your painting. Reading the values in nature takes a little practice, but once you get the hang of it, you'll do it without thinking.

VALUE GROUPS

In order to unscramble the great number of values in nature, it may be helpful to categorize them into groups. Classify all of the darks into one group, and all of the light values into another group. Try using two halftone groups, values between the lightest and darkest. All together, you will have four value groups—dark, middle dark, middle light and light (see value scale on facing page). Each group may be made up of several values, but sort them into the four groups. Simplifying in this way will help you manage a spectrum of values.

SQUINTING

If you're not sure whether a value is lighter or darker than another one, squint your eyes. Progressively closing your eyelids has the effect of forcing your subject into broad value patterns that are easier to read. Before beginning a new painting, take time to squint and simplify your scene into the four value groups. As you paint, repeatedly squint at your subject to discover the relationship of one value to another. When painting each shape, check the value by comparing it to the shapes you've already painted (lighter than this shape and darker than that one, but not as dark as this shape here, and so on). Reading the values in nature and fitting them into their corresponding groups takes a little practice, but once you get the hang of it, you'll do it without thinking.

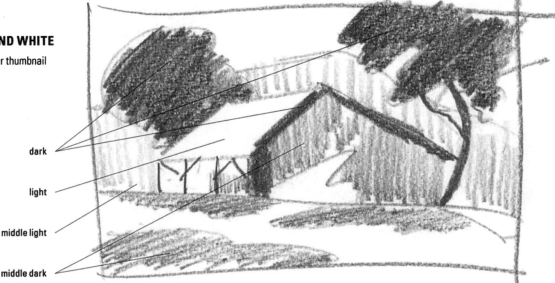

TWO VALUES PLUS BLACK AND WHITE
When planning your work, simplify your thumbnail sketches by using only four values.

dark

light

middle light

middle dark

Value Keys

The overall range of values within a painting is called a *value key*. You can vary the emotional mood your paintings convey by confining values to a limited range of the value scale. For example, a nocturnal or moonlight scene will use only values in the lower part of the scale (low key). A foggy scene might use only the upper part of the scale (high key) while a sunny day will employ a full range of values. Painting in a limited range of values not only conveys mood, but it is also a good way to improve the control of values.

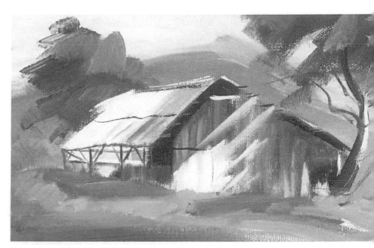

FULL RANGE OF VALUES
Uses values from the entire value scale.

A DARK TO LIGHT VALUE SCALE

light value group

middle light value group

middle dark value group

dark value group

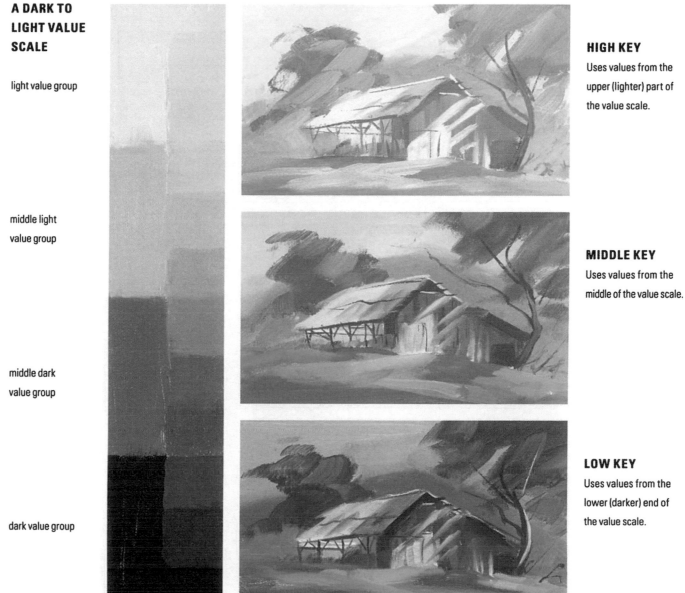

HIGH KEY
Uses values from the upper (lighter) part of the value scale.

MIDDLE KEY
Uses values from the middle of the value scale.

LOW KEY
Uses values from the lower (darker) end of the value scale.

Combining Value Keys

You can extend the range of moods you express and develop a subtler command of values by learning to combine value keys in a single painting. These two paintings are examples.

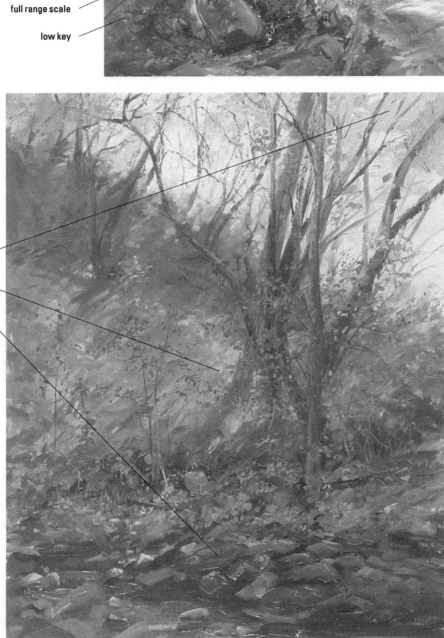

USE VALUE KEY TO FOCUS ATTENTION

Only the large rock is painted with a full range of values to help make it the most important part of the painting.

middle key

full range scale

low key

USE VALUE KEY TO CONVEY DISTANCE

Value keys range from low key in the closest parts of this painting to higher key in the distance.

high key

middle key

low key

Intensity

The third basic property of color is *intensity*. This term refers to how bright a color is. *Saturation* and *chroma* mean the same thing. Intensity is not the same as light, which is about value. Colors are most intense straight from the tubes. When we reduce the intensity of a color (or make it duller) we say we *gray* the color. Some combinations of colors become grayed, others do not.

A WORD ABOUT ADDING WHITE

When you add white to a color, the particles of pigment become spread over a broader area. This results in a color that is not only lighter in value, but is also not as bright. Colors lightened with only white are called *tints* rather than grays.

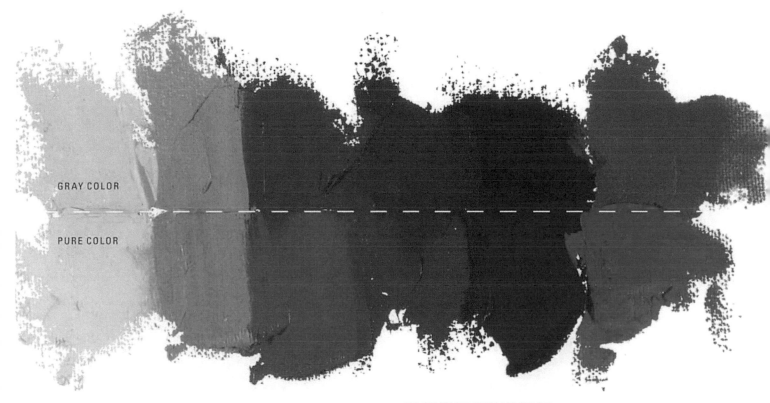

GRAY COLOR

PURE COLOR

TO GRAY OR NOT TO GRAY

Knowing how to mix grays is important because you will need to vary the intensity of your colors to convey the illusion of light. See page 46 to learn how to create grays, and also how to avoid graying your colors.

Crossing Primary Lines

Primary lines are the three lines on the color wheel that intersect with the three primary colors—yellow, red or blue. Whenever you mix one color with another and cross one of these lines, the result will be a color of reduced intensity. This occurs in every case without exception. (It is actually the equivalent of adding a small amount of the third primary color to the combination.) Color combinations that do not cross a primary line retain their intensity. Prove this to yourself by trying different combinations.

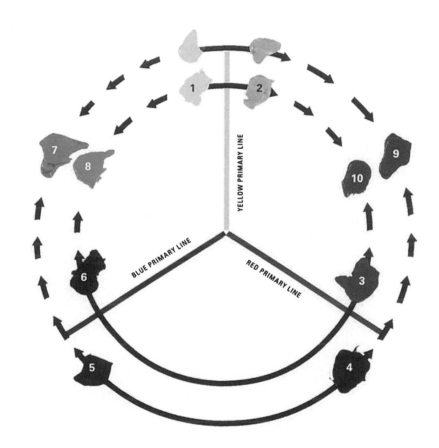

COMBINING PIGMENTS

Unless you're doing a stylized painting, you will rarely use colors straight out of the tubes. In most cases you will combine pigments. Many mixtures will need to be grayed to some degree. Know where the tube pigments locate on the color wheel (see page 41). When mixing colors, routinely think about whether or not you are crossing primary lines. The farther you reach across a primary line the grayer the resulting color will be. Cross two primary lines and the color will become very gray.

1 Cadmium Yellow Lemon
2 Cadmium Yellow Deep
3 Cadmium Scarlet (or Cadmium Red Light)
4 Permanent Red Violet (or Alizarin Crimson)
5 Ultramarine Blue Deep
6 Prussian Blue
7 this green is grayed because the combination has crossed the blue primary line
8 pure green does not cross a primary line
9 this orange is grayed because the combination has crossed the red primary line
10 pure orange does not cross a primary line

The Six-Color Palette

The six colors in these diagrams are all you really need. Yellows, reds and blues straddle each primary line. With them, you can mix clear, clean colors by staying between primary lines. Or, by mixing across the lines, you can get a nearly infinite number of grayed colors. The facing page demonstrates two examples of crossing primary lines.

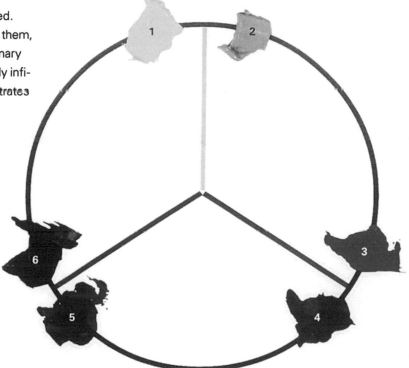

THE BASIC SIX

Work with only the six basic pigments plus white until you know them intimately. Don't be in a hurry to expand your selection of pigments. With only these six, it is easy to keep track of where the colors you're mixing are located on the color wheel in relation to primary lines. Learn how to use this basic palette well and you will be on your way to color mastery.

1 Cadmium Yellow Lemon
2 Cadmium Yellow Deep
3 Cadmium Scarlet (or Cadmium Red Light)
4 Permanent Red Violet (or Alizarin Crimson)
5 Ultramarine Blue Deep
6 Prussian Blue

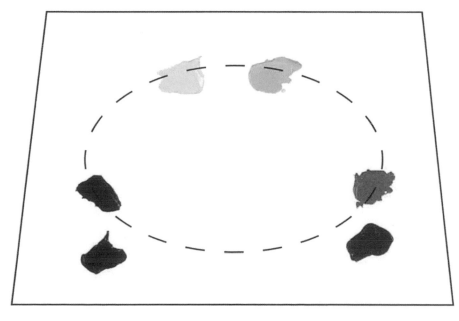

A HELPFUL ARRANGEMENT

Organize pigments on your palette in this way to help visualize their relationships to primary lines as you work. See the color wheel in your mind's eye.

Working With Color

As you work with color, keep your materials organized so you can concentrate on the work at hand. Develop good work habits. "It is easier to prevent bad habits than to break them," counseled Ben Franklin. Here are some color-mixing principles to think about as you learn to master this fascinating aspect of painting.

HOW DO YOU KNOW WHAT COLOR TO MIX?

Take your color cues from your subject. Compare the color of one shape with others. First, is it lighter or darker than neighboring shapes? Second, is it warmer or cooler? Third, is it brighter or grayer?

Favorite pigments and combinations can result in monotonous repetition from one painting to the next. Experiment with your mixtures to develop a broad repertoire of color possibilities, especially grays (colors of reduced intensity). You won't often use raw colors straight out of the tubes, but will adjust them by mixing with others to make them warmer or cooler and lighter or darker, and reducing intensity to some degree. If you are new to color mixing, start with the six-color palette shown on page 47 and explore mixing possibilities extensively before adding more pigments to your palette. As you combine pigments, think about where each is located on the color wheel in relation to primary lines so you know in advance whether or not mixing two particular colors together will cause them to become grayed (see page 46). How far you reach across a primary line determines whether your mixture will be grayed a little or a lot. Thinking this way helps you find the color you want with less trial and error.

A WORD OF CAUTION

If you know the color you've mixed is not the right color, don't put it on your painting. It usually helps to put a small dab onto your canvas to decide if it's right. But if it's wrong—too light or dark, too warm or cool, too bright or gray or whatever—keep working with it on your palette. Don't add more of this and that, hoping for something to happen. Think. If you're not sure which combination of pigments will yield the color you want, try small, experimental combinations before mixing a larger amount. If a combination doesn't work, remove it from your palette and try again. If you've painted it onto your canvas and then realize it is wrong, scrape it off and repaint. Colors often look right when first applied but need some adjusting as the painting develops because every color affects every other color. Stay flexible and take these changes in stride. Colors that are glaringly wrong are best fixed right away. If they're off by only a little, you may decide to let them go until more of the canvas is covered.

STRONG AND WEAK PIGMENTS

Some pigments, such as Phthalo Blue and Phthalo Green, Prussian Blue and Terra Rosa, have powerful tinting strengths. Pigments with less powerful tinting qualities are Cobalt Blue Light, Ultramarine Violet and Cadmium Yellow Lemon among others. When mixing a strong pigment with a weaker one, you will need to compensate for the differences in tinting power. Start with the weaker pigment and progressively add small amounts of the stronger one until you find the balance you are looking for. Doing it the other way around can result in an unnecessarily large pile of paint by the time you arrive at the color you want.

MIXING WITH THE PALETTE KNIFE

With the colors arranged in a logical order around the edge of your palette, take the amount you need from one of these colors with a palette knife. After placing it on the mixing area, wipe the blade before reaching for the next color to avoid contaminating your supply. Don't stir the paint in a circle as if you were mixing cookie dough. Instead, if the knife has an offset blade, place the blade at about a 45-degree angle with the edge against the palette and push the piles of color together. Then, squish down. Come at your pile of paint from different directions, repeating this motion as many times as needed to mix the colors together. If you use a straight-bladed knife, hold it so the blade is nearly parallel with the surface of your palette and slide the knife under the colors you want to mix together. Then, lift the pile of paint up, turn the knife over and squish it down. Repeat from different directions as needed.

MUDDY COLOR

Muddy colors are those that are overly gray. A common cause is brushing colors together on the canvas that cross primary lines. The more you rub and scrub them together, the muddier they become. Put the paint on and leave it alone.

WARM LIGHT
Yellow light influences every color in this scene.

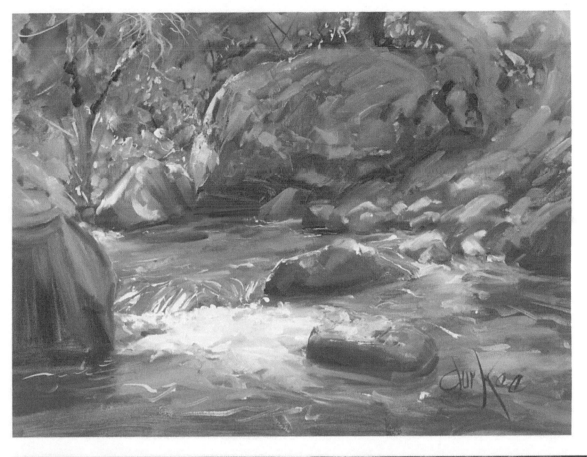

COOL LIGHT
The light source for this painting is cool.

EARTH COLORS

A second way to mix grays is by using earth colors, like Yellow Ochre, Raw Sienna, Burnt Sienna, Terra Rosa, Venetian Red, Burnt Umber, etc. These pigments are already grayed the way they come out of the tubes. When you add one of them to a color of high intensity, you get a color that is grayed. Keep in mind, however, that each of them is also a particular hue. Burnt Umber is a red, Burnt Sienna is an orange, Raw Sienna is a yellow and so on. Adding a bit of earth color, say Burnt Umber, to pure Cadmium Red will result in a grayed red. Add Raw Sienna or Yellow Ochre to any blue and you'll get a gray-green.

Using earth colors to alter other pigments without regard for their relationship to primary lines can result in dull, lifeless paintings. First, become proficient with the six-color palette (see page 47). Later on, when you do add earth colors, keep track of how they relate to the color wheel in the same way you do with other pigments.

AERIAL PERSPECTIVE

With distance, contrasts are lessened. Dark values especially become lighter, and lights become slightly darker. Also, colors usually become cooler and less intense with distance. This is because the air itself is composed of layers of moisture and dust particles through which we look. Spend time in nature looking for the subtle effects of atmospheric haze.

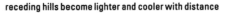

receding hills become lighter and cooler with distance

as the flat plane of land recedes, you see it through a thicker layer of moist air

PAINT THE AIR

Sometimes the effect of aerial perspective is quite pronounced, as it is here, and other times it is more subtle. By squinting your eyes, even on a clear day you can usually discern a narrowing of value contrasts as objects recede.

The Harmonizing Influence of Light

Place a blue object near a window without direct sunlight. Now light it with an incandescent lamp and watch how yellow light combines with the blue object to make it appear more green. Place a white sheet of paper half in sunlight and half in shadow, and see how the lighted and shaded halves take on altogether different colors, neither of which is white. Whether warm or cool, the color of objects varies with the color of the light. Colors in nature are always in harmony with each other because colors shift just a little toward the color of the light.

NEUTRAL COLORED LIGHT

Subtle color predominates in this painting. Light filtered through cloud cover is neither warm nor cool.

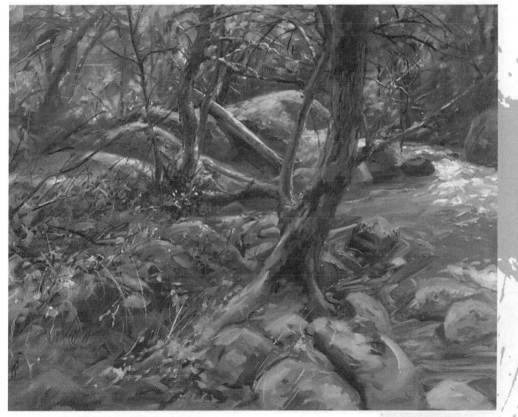

"The color of the object illuminated partakes of the color of that which illuminates it."

— Leonardo da Vinci

COOL LIGHT, WARM LIGHT

Cool light from the blue sky predominates. Sunlight filtering through the trees is warm. Warm grass tones are not as warm as the sunlit grass.

Painting the Light

While you can't actually paint light, you can paint what it does. The more you understand how light affects the appearance of your landscape the more convincing your paintings will be.

WARM AND COOL

Warm and *cool* are simply the location of hues on the color wheel. Beginning with blue, the coolest color, move around the wheel in one of two directions—through violets toward warmer reds and orange, or moving from blue in the opposite direction through blue-greens toward yellow-greens then yellows and orange.

WHAT COLOR IS THE LIGHT?

Some artists think of local color as "the color of an object without the influence of light or shadow." This may be a useful definition, but local color is always influenced by the light. Without light, we see nothing, and light is always a particular hue. If the color of the light is yellow, then as the object you are painting changes from shadow to light, the hue of the color will move around the color wheel in the direction of yellow. If, on the other hand, the color of the light is blue, then as your object changes from shadow to light, the hue will move around the wheel in the direction of blue. These changes of hue, influenced by the color of the light, may be very pronounced or quite subtle depending on the intensity of the light, but they are nearly always detectable. Look for these color changes. (A possible exception to the above is on overcast days when the light spectrum is more evenly balanced.)

SUNLIGHT

When painting outdoors on a sunny day with a clear blue sky, imagine you are working with two light sources. Each is a different hue. Sunlit shapes will be strongly influenced by the warm hue of sunlight. Shapes not directly lit by the sun will take on the cool light of the sky. This does not necessarily mean sunlit shapes are yellow and shadows are blue. However, it does mean that the hue of light-struck objects will shift in the direction of warm, and shadow areas will shift toward cool.

CAST SHADOWS

Cast shadows are often lighter and cooler when farther away from the object casting them. This is because they pick up more cool light from the blue sky. If you squint your eyes you can see how obvious this is. Warm sunlight will often reflect off objects and into shadows causing the value and hue of colors to become lighter and warmer. When painting these reflected lights, use care not to make them too light. The value change is usually only a step or so up the value scale. Again, squint your eyes and see how little value change actually occurs in reflected light. While rendering these color changes will add a note of authenticity to your work, don't get lost in the minutiae of small details. Develop your painting with broad, simple patterns of value. As you progress, you can paint into these overall values with minor variations. It is usually best to understate these variations. Retain the overall value structure of your painting at all costs.

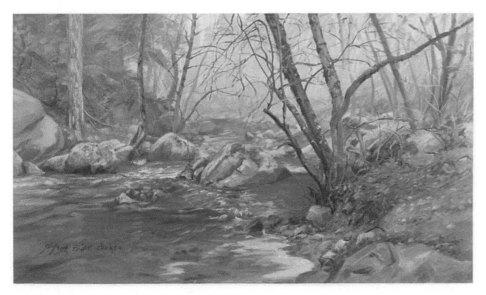

VALUE KEY CREATES THE MOOD

This foggy-day riverscape was painted in a predominantly middle value key. Only the main tree, foreground and a few other dark accents deviate from middle key. While painting this scene, the sun broke through for a few moments and I saw an entirely different expression of the subject. So I returned on another day to paint it again. The result is on page 55.

View from Beneath Middle Fork Bridge
oil on hardboard panel
19" × 30" (48cm × 76cm)

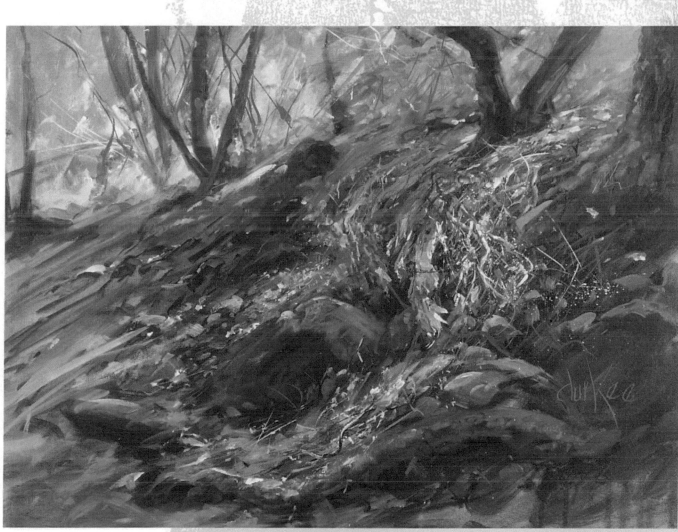

Riverbank
oil on canvas
24" × 30" (61cm × 76cm)

TWO LIGHT SOURCES
Some parts of this scene are lighted by warm light from the sun; other parts are lighted by cool light from the sky.

Closing Remarks

The visual characteristics of nature discussed in this chapter are not hard-and-fast rules. There are many exceptions. However, by knowing in advance how nature typically behaves, you have some clues about what to look for. There is one hard-and-fast rule: *look before you paint*. Don't paint by formula; look deeply. Try to discover the *why* of the colors you see. As you gain understanding, you will learn to deviate from what you actually see in order to emphasize the moods of nature. You will begin to assert more of your own personality into your work. Painting will become an intimate dialogue with Nature. She will say, "I am this," and with brush in hand you will reply, "And I feel this."

Think hue, value and intensity. Take one idea at a time from this chapter and work with it until you thoroughly understand it. Do a series of studies using a limited range of values—low key, middle key and high key (see page 43)—and practice mixing grays. Always visualize the color wheel and especially the location of primary lines. As with any skill, you will progress in direct proportion to the amount of time you devote to learning. Skillful color mixing is largely a matter of practice. Before long, you will work with color as fluently as you write your own name.

Chapter Five

composition

CHOOSING WHAT TO PAINT IS THE BEGINNING OF AN INTIMATE RELATIONSHIP. IF YOU DON'T FIND YOURSELF FALLING IN LOVE WITH YOUR SUBJECT, MAYBE IT'S TIME TO LOOK FOR SOMETHING DIFFERENT TO PAINT. You can paint what others will be pleased by, but if you paint in order to please others, then what is authentically yours will be missing. To begin composing, ask yourself why you want to paint this particular subject. Whether you're attracted by an arrangement of colors and shapes or simply by a quality of atmosphere, try to say what, specifically, you want your painting to express.

Composition, in the broadest sense, is deciding what to put into a painting and what to leave out. It is deciding where to locate objects on the canvas and how big or small to make them. The laws of composition are simply guidelines. They show how the parts of a painting fit together most pleasingly—most of the time. Although it is important to understand the agreed upon conventions, your compositions may deviate from what has been tried before.

Finding your way into a composition will depend on your personality. A logical, analytical person may tend to overplan in order to stay in control and feel safe. In doing creative work, there is a point where you need to go into the unknown, to take risks where the results are unpredictable. Without risk, a painting may be technically correct, but without life. On the other hand, if it is your nature to be more intuitive, there will be a point where you will want to consult your analytical side. Trusting intuition alone, you may occasionally produce a highly original painting, but more often the work is likely to be disorganized.

In composing a landscape from life, find the most compelling point of view for your subject and imagine boundary lines framing the area (see page 27). Select and arrange from nature those things that say what you want to say and discard the rest. It is less important that the final painting exactly reproduces your subject than that it is interesting to look at. Thumbnail pencil studies are an enormous help in the planning stage. A well conceived beginning is the most important phase of your painting project.

A NATURAL COMPOSITION

To compose your painting, you can either move objects around on the canvas, or you can move yourself around until you see the arrangement that best expresses what you want to say. Or you can do both. This painting composed itself.

"Remember that the most realistic landscape in the world can be a work of art, but do not think that because a landscape is 'real' that it is a work of art. A true picture is one in which so-called natural elements are made to function as an idea."
— John F. Carlson

My Hiding Place oil on hardboard panel | 24" × 30" (61cm × 76cm)

The Picture Area

Every composition begins with the area of the canvas itself—the *picture area*. The objects you place within this area have greater or lesser importance according to how big or small you make them. A small object on the canvas will be of less consequence than the same object occupying nearly the entire area of the canvas.

The vantage point for these two sketches is from a narrow bridge footing next to the north fork of the Mokelumne River, the northern boundary of Calaveras County, California. The top painting on the facing page is a sketch looking three hundred yards downstream toward the same bridge. The rock on the left in that study is the same big rock, only it plays a less important role because of the smaller amount of picture area it occupies.

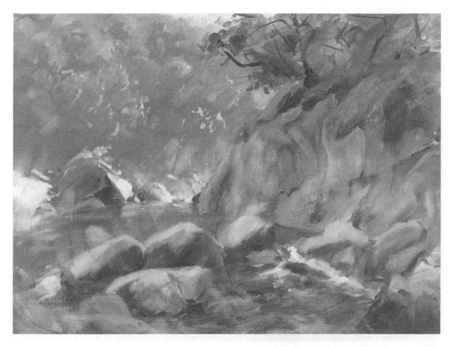

I DIDN'T THINK

These two studies were done in preparation for a large painting. I was especially impressed by the huge rock on the right side of the river and I wanted to express the immense size of this hunk of granite with full grown oaks on top. Here, the big rock, river and distant hill are close to equal in the amount of picture area they occupy. Nothing stands out as most important.

TAKE TWO

Now the big rock dominates the picture area because it is the largest shape. On this second try, the eye level is lower and the rock is larger in relation to the overall picture area. The trees on top of the rock are smaller in relation to the size of the rock to help it seem larger. This composition conveys more of the feeling I was after. (More careful planning, perhaps with a few thumbnail pencil studies, would have saved a day of work.)

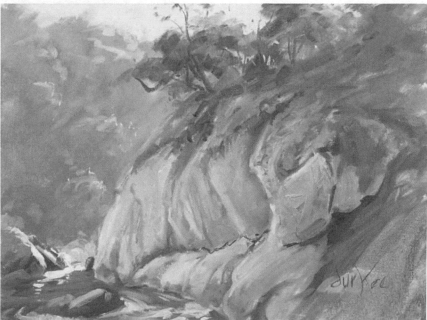

Format

Your painting begins when you stand before your landscape and feel your way into it. Most landscapes are horizontal because the horizon stretches out from side to side. On the other hand, vertical may work best for a tall tree, a church steeple or a standing human form. When planning your painting, try both horizontal and vertical thumbnail sketches. The best choice will usually be apparent.

UP AND DOWN, OR SIDE TO SIDE?
This subject suggested a vertical format because the river runs straight from the foreground into the distance. Explaining logically why a vertical format works here is easy enough, but the decision to paint it that way in the first place came more from an internal response to the subject—it felt right.

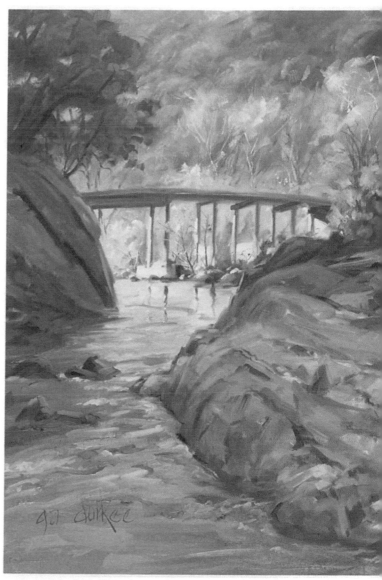

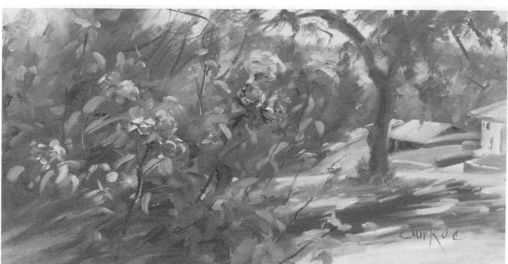

TRUST YOUR INTUITION
The subject itself will often suggest a format. Here, the rose bush is vertical in shape, but the long horizontal format allows some context for the roses. There certainly were other format possibilities for the subjects on these pages. When choosing a format, there are no hard-and-fast rules. If it looks right, it is right.

Keys to Composition

The principals of composition are not absolutes. Hold them lightly. Sketch your picture idea intuitively, and then analyze your work to see if some of the ideas shown on these pages will help make your composition more interesting. Stay flexible and grow your design through a series of sketches. You don't need to employ all of these devices in every painting you do—emphasize one or two. When the rules don't apply, make up new rules.

ASYMMETRY

Locate objects off center. Counterbalance with others. Objects divide spaces; divide most of them unequally. Objects are "heavy" not only according to their physical size, but also how dark they are and how much they contrast with their surroundings. Bring your work in progress into balance by adjusting value contrasts—more contrast, more weight; less contrast, less weight.

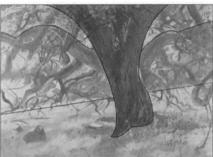

THINK BIG

See broadly and simply. Visualize complex subjects as a few large shapes.

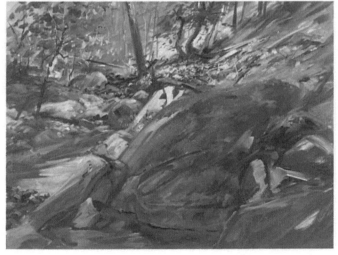

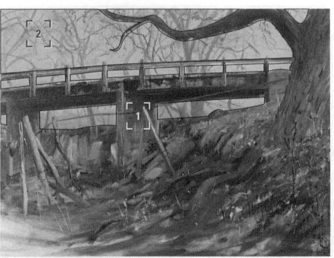

FLOW

Flow is the way things fit together in a composition to pull you to a particular spot or from one place to another (also called "eye travel"). Soak up your landscape scene and feel it. At first, the flow may be ever so slight, an ephemeral sensing of movement. As you look more deeply, you'll experience an almost palpable motion, thrusting here and yielding there. This sense of flow is part of the idea of your composition.

POSITIVE AND NEGATIVE SHAPES

Some parts of the picture area contain objects (*positive shapes*); other parts are empty spaces (*negative shapes*). Aim for an interesting variety of positive shapes and the spaces around them. It's okay to shift things about for a pleasing asymmetry.

1 positive shapes
2 negative shapes (outlined and shaded in blue)

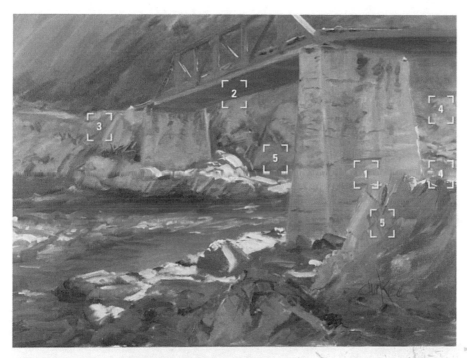

DEPTH

Depth is the imagined movement into the painting. Here are five ways to communicate the illusion of depth:

1 **OVERLAPPING** (objects in front of, or behind other objects)

2 **LINEAR PERSPECTIVE** (objects become smaller as they recede)

3 **AERIAL PERSPECTIVE** (colors become lighter, cooler and less intense with distance)

4 **EDGES** (softer edges as objects recede; harder edges as objects advance)

5 **TEXTURE** (less texture as objects recede; more texture as objects advance)

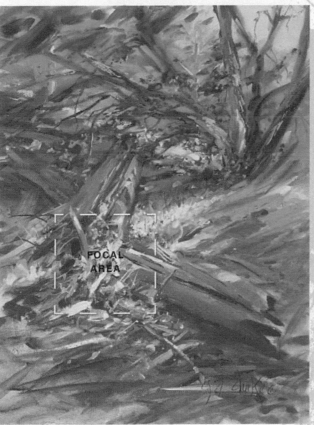

FOCUS

When you want to be heard, you raise your voice; do the same in your paintings. Here are four ways to make your painting shout. Concentrate these devices in your focal area:

1 stronger contrast

2 more intense color

3 heavier paint

4 sharper edges

Closing Remarks

There are no "shoulds" in this chapter. As a creative artist, you will use ideas about composition to express your personal view of the world. Before beginning a painting, think about what you want it to say. Why do you want to paint this particular subject? Is it the pattern of values you find most interesting, the play of light and color, the juxtaposition of forms, an indefinable flow of movement or something else? Whatever it is, this is the idea of your composition—the one thing you want the painting to get across. Choose a point of view and arrange objects on the canvas to give prominence to your idea. Rather than trying to say everything you know about the subject, say one thing. Everything else is of lesser importance. Aiming toward your idea, you have a destination— something specific to accomplish.

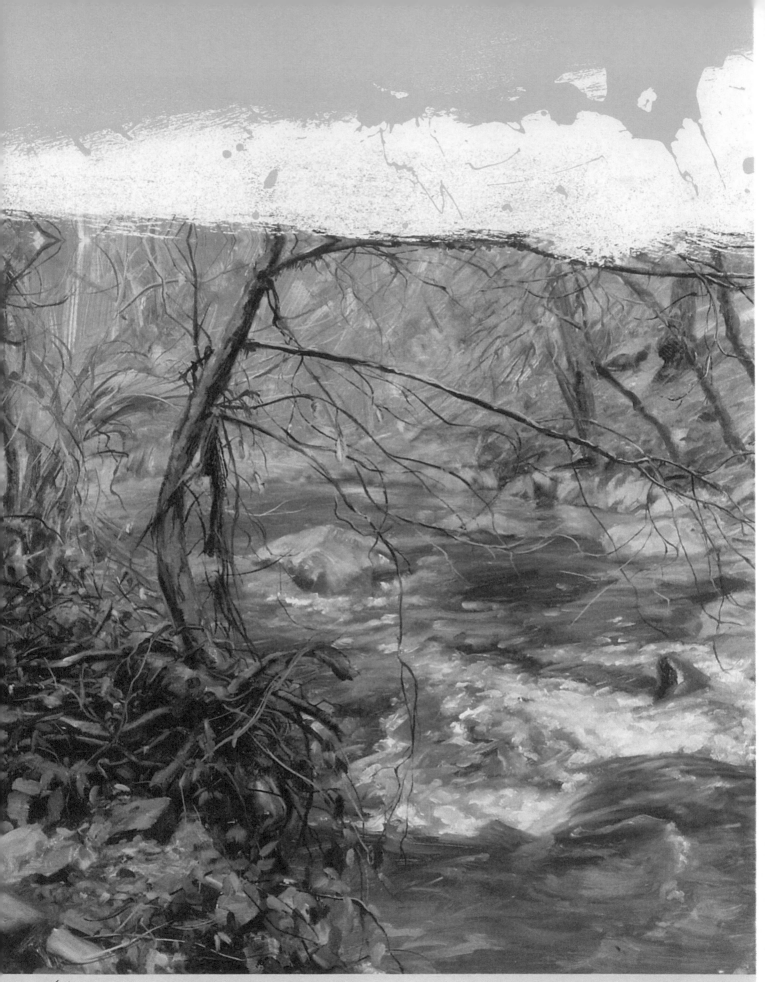

Autumn River oil on hardboard panel | 19" × 30" (48cm × 76cm)

part two: 9 painting demonstrations
Basic and Advanced Techniques

*T*he following pages demonstrate some of the more useful painting procedures. There is no one right way to paint. Many artists vary their painting methods according to the needs of the subject at hand.

The first demonstration explains a basic working procedure in a logical progression of tasks to accomplish—first things first, then second, third and so on. The series of orderly stages will help less experienced painters avoid confusion. Later on, the basic approach can be modified as needed.

The second demonstration builds on the basic approach, and the remaining seven show ways I have tailored my methodology to a variety of painting situations. Some of these adaptations are not clear-cut painting systems but improvisations of the moment. Rather than imitating my way of working, understand the underlying principles. Then apply these principles in your own way. Many of the demonstrations employ advanced painting techniques. Learning these techniques may take some study and practice. Because reading alone will not make you a better painter, immerse yourself in the demonstrations and then paint a few paintings. Come back for a second reading. Through back-and-forth repetition, your understanding will deepen.

The way to paint accomplished paintings is to practice often. Rather than spending an inordinate amount of time on a large, elaborate composition, use the same amount of time to do a number of small studies depicting simple subjects. This will allow you to repeat the entire painting process several times instead of only once. Don't labor over a painting, straining for precision. Paint it and stop. Paint another one. For the first hundred or so, volume is more important than perfection. You learn to paint by painting.

basic approach

Materials list

PIGMENTS

Cadmium Yellow Lemon

Cadmium Yellow Deep

Cadmium Scarlet
 (or Cadmium Red Light)

Permanent Red Violet
 (or Alizarin Crimson)

Ultramarine Blue Deep

Prussian Blue

Titanium White

BRUSHES

a selection of small, medium
 and large brushes (see page 14)

TOOLS

painting knife

rag

mineral spirits or turpentine

This first project demonstrates a simple step-by-step painting procedure. The actual process of developing a painting needn't be as rigidly structured as the steps may imply; there will be some inevitable merging and overlapping from one step to the next.

Since creativity is an unbounded expanse of possibility, it is understandable that you may not want boundaries with square corners stretched around your imagination. Yet, learning the technology of painting requires periods of sustained effort following predetermined methods. Though it may feel awkward or uncomfortable, you can't learn something new without doing something different. Throw your brushes on the ground and pull out your hair if you need to. Take a break and then try again. Your ability to visualize develops faster than your know-how. Through repeated effort, rather than fleeing from the invitation to grow beyond yourself, you will become attuned to the challenge and more able to tolerate not knowing.

It's okay to paint along with me, copying what I've done. Before long, though, take your easel and paints into nature, even if it's your backyard, and try your hand at painting from actual subjects. There is one particular challenge that is unique to painting from life: the scale of values observed in nature ranges from darker than black paint to many times lighter than white paint. Because it is impossible to duplicate this expanse of dark to light, use reference values as explained in the demonstration to convert Nature's values into the narrow range of values that are possible with the paint. If you work from photographs, you don't have this particular challenge. The values in the actual subject have already been reinterpreted into the same range as the paint values. "So why not just paint from photographs?" you may ask. Personally, I choose to paint from life because many of the visual subtleties observed in a real-life subject are not recorded in even the best photographs. If you can't see it and feel it, how can you paint it? It's your choice whether to paint from life or photos. Painting from life is certainly more challenging because of the value disparities, and because as the world turns the light changes, but it is also more rewarding. Either way, knowing how to use reference values will be extremely helpful in later demonstrations. If you thoroughly study and practice only this one project, you will know enough to become a respectable painter.

1 ∧ PLAN YOUR COMPOSITION

Do a few thumbnail sketches of the subject before you set up your easel (see page 36). Try different points of view; there may be a better angle than your first idea. Sketches needn't be large or elaborate; just find the most pleasing arrangement of major shapes and work out a strong pattern of values. Even though you may be excited to get started painting, a half hour of planning will save time in the long run and will result in a better painting. Get in the thumbnail sketch habit.

2 < TONE THE CANVAS

With a painting knife, mix a violet color by combining Ultramarine Blue Deep and Permanent Red Violet (or Alizarin Crimson). Add a small amount of this violet to Cadmium Yellow Deep to create a grayed-yellow toning color similar to Yellow Ochre. Put some of this mixture aside on the palette for later; apply the rest of it generously to the canvas with the painting knife. With a rag dipped in turpentine or mineral spirits, spread the paint over the canvas and rub it nearly dry. This will lower the value from stark white, making it easier to gauge values, and also form the basis of the color key for the painting.

3 < PLACE THE MAIN SHAPES

Using the leftover paint from step 2, sketch the main shapes of the composition with a brush that feels comfortable. A small sable brush makes a fine line; a larger bristle brush makes a wider line. Work broadly and simply, placing the large overall shapes first and leaving out details. To make adjustments, simply wipe off and redraw until you get the placement you're after.

4 < DEVELOP SECONDARY SHAPES

As you develop more shapes, don't be overly concerned with the thickness of the lines; these first indications are simply a way to get the painting started. Although a wide line at some point becomes a shape unto itself, think of the shapes that the lines define rather than the precise edges of shapes. The lines will soon disappear beneath subsequent layers of colored pigment.

Light: Titanium White with a little Cadmium Yellow Deep

Middle Light: Cadmium Yellow Lemon and a little Cadmium Yellow Deep plus a touch of Prussian Blue

Middle Dark: same as the color the canvas is toned with

Dark: violet made with Ultramarine Blue Deep plus Permanent Red Violet is grayed with just a touch of Cadmium Yellow Deep

5 ∧ ESTABLISH REFERENCE VALUES

Study the subject and choose a dark shape, a light shape and at least two incremental halftones. Paint these shapes onto the canvas with a no. 6 flat bristle brush. These first indications are called *reference values*; they serve as a value scale built into the painting. You will compare all other values to these first light, middle and dark ones before painting them onto the canvas. The lightest and darkest reference values establish the upper and lower limits within which you will work.

1 Prussian Blue + Cadmium Yellow Deep
2 Prussian Blue + white
3 Cadmium Scarlet + white + a touch of Prussian Blue
4 Cadmium Yellow Lemon + a little Prussian Blue
5 Permanent Red Violet + a touch of Prussian Blue
6 Ultramarine Blue Deep + Permanent Red Violet + a little Cadmium Yellow Deep

6 < USE REFERENCE VALUES TO DETERMINE OTHER VALUES

Begin covering the canvas, shape by shape. The sky in the actual subject is lighter than the shadow side of the house and darker than the sunlit side. Since two of the reference values established on the canvas are the shadow and light sides of the house, mix a value of paint for the sky that is between these two. This is the key to using reference values. The yellow-green to the right of the house falls between the sky value and the sunlit side of the house. The dark tree to the left of the house is darker than the shadow side of the house and lighter than the darkest reference value, and so on.

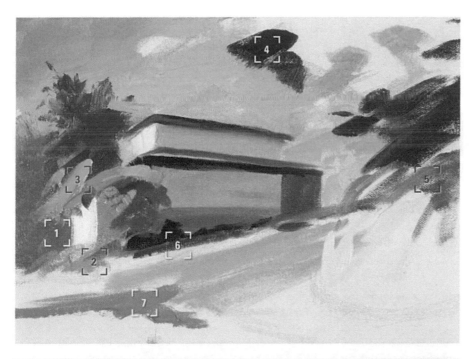

7 ◁ CONTINUE LAYING IN EACH VALUE
Paint more distant shapes first and closer shapes next. Use larger bristle brushes for large shapes and smaller ones for small shapes. To keep the colors on the palette clean, rinse your brush in the brush washer or wipe it on a rag before changing from one color to another. Values will often look right on the palette, but wrong on the painting, so mix colors as you go and try them out one at a time. Before painting a shape, put a small dab of paint onto the canvas and check it against other values.

1 Ultramarine Blue + Permanent Red Violet + a little Cadmium Yellow Deep
2 Cadmium Scarlet + Cadmium Yellow Deep + a touch of Ultramarine Blue Deep
3 Cadmium Lemon + Prussian Blue
4 Ultramarine Blue Deep + Cadmium Yellow Deep
5 Ultramarine Blue Deep + Prussian Blue
6 Ultramarine Blue Deep + Permanent Red Violet
7 Permanent Red Violet + Prussian Blue

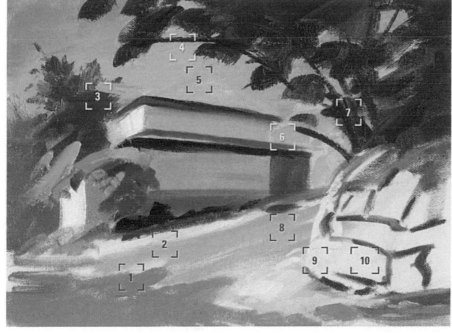

8 ∧ TAKE A BREAK
Now that the canvas is covered, put your brush down and study the painting. Ask yourself questions like, *Is the road too dark, too cold? Is the warm strip of land in front of the house light enough, bright enough? Are there drawing errors that need to be corrected?* Answers to these and similar questions will inform your choices as you map out the changes needed. Because each color you paint changes the balance of the whole composition, making adjustments is simply part of the painting process.

1 hard edges need softening
2 could be lighter and brighter
3 tree needs to be painted over roof
4 tree limb too big and too horizontal
5 roof is too dark
6 edges between roof and background need softening
7 edges of tree silhouette need individual leaves
8 road is too dark and too cold
9 receding end of rock wall will need to be a soft edge
10 too soon to know how to develop the rock wall, save it for later

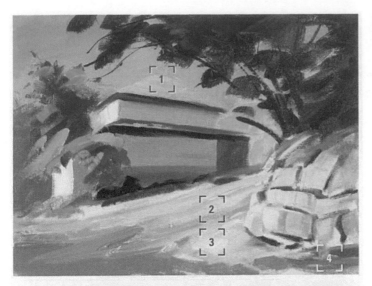

9 < BEGIN PULLING THE PAINTING TOGETHER

In step 8, the road was too dark and a little too cold. Paint a lighter, warmer road color up and into the rock wall with a no. 10 bristle brush to help the road feel like it goes behind the wall. Put the paint on and leave it alone. Let the characteristic ridges left by the bristle brush become part of the finished painting. When you paint one color over another, wipe the brush off and reload it between each brushstroke to avoid mixing the new color with the underlayer.

1 add Cadmium Yellow Deep + white to roof color
2 add Cadmium Yellow Deep + white to road color
3 Cadmium Yellow Deep + Cadmium Scarlet + white
4 Cadmium Yellow Deep + Cadmium Scarlet + Permanent Red Violet

10 < BUILD TEXTURE

Develop textures where you want the viewer to focus, especially in the parts where the sunlight strikes the subject, and leave the rest of the painting less refined. To create a variety of textures, use the flat sides, edges and corners of the entire range of brushes and painting knives.

By this stage you have entered the real dance of creativity and have separated yourself from dependence on your subject. No one can tell you how to do your personal dance with your chosen subject. Your skill and sensitivity will develop over time. Trust your intuition as you feel your way along.

1 Cadmium Yellow Deep + white
2 texture and accent brushstrokes
3 cake-frostinglike knife stroke
4 add Cadmium Scarlet to original roof color to make it darker
5 soften edge of roof

11 > ADD FINISHING DETAILS

With a brush the same width as a window, paint the windows with one fluid stroke, then add color variations. Paint the rock wall thinly at first with bristle and sable brushes. To create a rough texture, lightly skim the surface of the underlayer of individual rocks with a 1-inch painting knife, adding color variations. Then refine with your smallest brushes.

When you have adjusted values and colors, built textures and added just enough detail to explain more important parts of your painting, stop. Sign your name well away from the borders of your painting to avoid crowding the frame.

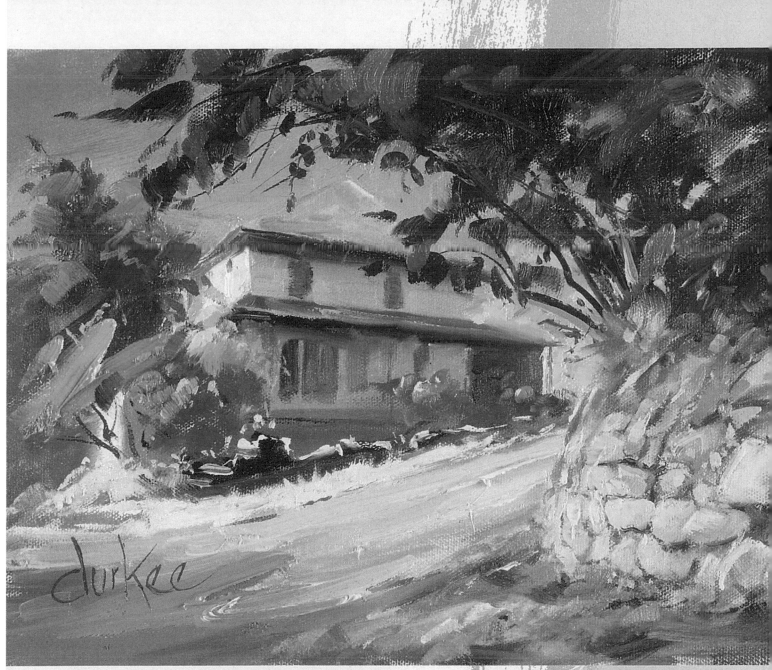

durkee

Moke Hill
oil on canvas
9" × 12" (23cm × 30cm)

Let's Review

With this basic procedure, establish reference values first. Then, using the reference values to help gauge other values, paint broad, simple masses covering the entire canvas. Next, make corrections as needed. Only then do you explain textures and details.

I earnestly suggest you study this demonstration until you thoroughly understand it, then do fifteen or twenty simple studies no larger than 9" × 12" (23cm × 30cm) using the approach shown. Try painting from life, not from photographs, and concentrate on developing each study through a series of orderly stages.

classical adaptation

Materials list

PIGMENTS

Cadmium Yellow Deep

Yellow Ochre Light

Raw Sienna

Transparent Oxide Red

Cadmium Scarlet
 (or Cadmium Red Light)

Terra Rosa

Permanent Red Violet
 (or Alizarin Crimson)

Ultramarine Blue Deep

Cobalt Blue Light

Prussian Blue

Viridian

Titanium White

BRUSHES

a selection of small, medium
 and large brushes (see page 14)

TOOLS

painting knife

rag

mineral spirits or turpentine

This approach is a contemporary modification of the classical painting technique. It allows for a high level of safety with room for an expressive outcome. The true classical technique is slow, painstaking and extremely safe. After building a smoothly refined monochrome foundation of grays, layers of color made transparent with oils and varnishes are glazed over the previously perfected underpainting. Because each layer of color needs time to dry, it can take months to complete a single painting. The achievements of classical painters were magnificent, but these great works belong to another age.

Today, we live in an age of speed and quick results. As an artist of your age, you will work in a way that is less ponderous. Rather than aiming for a painting surface that is as smooth as a polished table top, the texture of your paint and the evidence of your own hand will reflect your personality, as well as the time in which you live.

Adapting useful parts of the classical technique gives you a way to resolve many of the uncertainties of a composition even before squeezing ropes of color onto your palette. You will actually paint two paintings, one over the top of the other, first working out shapes, values and edges without needing to deal with the challenges of color at the same time. Thinning the paint with turpentine or mineral spirits will allow you to achieve variations in value by using the white of the primer coat rather than adding white paint. It will be easy to make changes by wiping off and moving shapes around. You'll develop a strong pattern of values and decide where to de-emphasize parts of the composition with softer edges, and where to use harder edges for greater impact. Without time spent mixing colors on the palette, the first stage will go quickly, so light and shadow areas can be anchored down before the world turns and the look of things changes. After completing the underpainting, you will have a map to guide the application of subsequent layers of colored pigment.

A beautiful color harmony will emerge by allowing some of the underpainting to show through to the finished work. As you develop a painting in full color, you will also create a seductive paint surface by contrasting the transparent underpainting with opaque brushwork and judiciously applied thick layers of pigment laid on with brush and knife. With this demonstration you begin your exploration of advanced oil painting techniques.

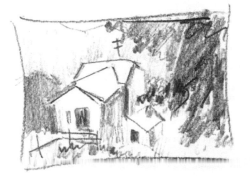

1 ^ BRAINSTORM WITH THUMBNAIL SKETCHES
Take time to do a few thumbnail studies. A well conceived beginning gives you a better chance at a successful outcome.

2 < LOCATE THE MAIN SHAPE
The white of the primer coat will represent the lightest value, so don't tone the canvas. Using only Transparent Oxide Red and no white, thin the paint on the palette with a no. 10 flat—more turpentine for lighter values, less or none for darker ones.

The barn is the main object of interest in this composition, so block it in first with a no. 10 flat bristle brush. Use the method of measuring shown on pages 28–31, aiming for solid shapes rather than outlines. Concentrate on placing the large shapes and focus on how light or dark they need to be.

3 < PLACE THE SECONDARY SHAPES
With a no. 10 flat bristle, paint the trees to the left of the barn. This also defines the upper edge of the hill to the left of the barn. Then locate the road. It's okay to use a few lines here and there, but try mainly for shapes of value. If the paint application is too dark, lift some of it off with a dry rag. Place a few fence posts with a no. 6 flat bristle brush on its edge. Already the painting is starting to come alive.

4 < KEEP THE PAINT THIN

Paint the sky just slightly darker than the white canvas, and soften the edges of the trees. Use the edge, tip and corners of the no. 10 flat bristle to indicate dark thistle plants in the lower right of the composition. To paint the fence overlapping the barn, moisten a no. 4 flat bristle brush with turpentine and lift the paint off the canvas with the brush on edge. Do the same for the upper barn roof overhang. Control how wet the brush is by dabbing it on a dry rag. Let the canvas dry for a day or two.

5 < ESTABLISH REFERENCE VALUES

Except for a few smaller brushstrokes, use a no. 10 flat bristle almost exclusively to paint the entire painting. Paint the two strongest contrasting values first—the dark green on the left side of the barn and the light value on the sunlit side of the barn.

Now, establish middle light and middle dark reference values of the sky and shadow side of the barn. Use care not to completely cover the barn underpainting. So far, you have four contiguous reference values with which to compare other values as you further develop the painting.

1 white + Cadmium Scarlet
2 dark green mixture of Prussian Blue added
 to Cadmium Yellow Deep + Cadmium Scarlet
3 Prussian Blue + a touch of Ultramarine Blue
 Deep + white
4 Prussian Blue + Ultramarine Blue Deep +
 a little Terra Rosa + white

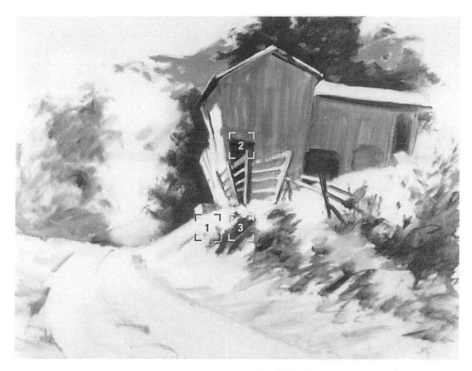

6 < EXTEND YOUR REFERENCE VALUES

Broaden the areas covered with reference values before painting the sky to help you avoid a distortion of your color sense caused by all that overpowering blue sky. Extend the shadow side of the barn and the dark green of the tree over broader areas, retaining some of the underpainting. Paint a few "sky holes" into the tree. Before beginning the thistle plants in front of the fence, observe the subject with squinted eyes and notice that they are a little lighter and warmer than the dark tree.

1 white + Cadmium Yellow Deep
2 Transparent Oxide Red + Ultramarine Blue Deep
3 Viridian + Raw Sienna

7 > PAINT THE SKY

Add progressively more white and touches of Yellow Ochre Light to the sky as you approach the horizon, using only a moderate amount of paint. Reserve the thicker paint applications for the foreground areas. Give the far distant hill a very soft edge where it meets the sky using a no. 14 long sable filbert. Scrub thin layers of paint onto the tree shapes as silhouettes. If the brush accidentally picks up some sky color, wipe it off on a rag before continuing.

1 add Yellow Ochre Light + white to sky color
2 Prussian Blue + Terra Rosa + white
3 Viridian + Raw Sienna + a touch of Cadmium
 Yellow Deep

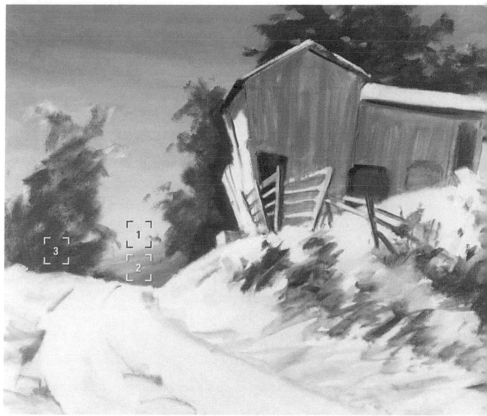

8 < PAINT THE CLOUDS

Brush cloud shapes directly into the blue sky with the no. 10 flat bristle brush either held flat or on edge as needed. Wipe your brush on a rag between strokes and then reload it to avoid mixing the cloud and sky colors together. Soften cloud edges with a sable filbert. Bring some cloud and sky color into the trees and then paint the tree on the left over and into the sky. Use the tip and corners of a no. 10 flat to develop leafy edges where trees meet the sky and soften tree edges by carefully blending with the sky.

1 white + a balanced gray mixed with Viridian + Permanent Red Violet

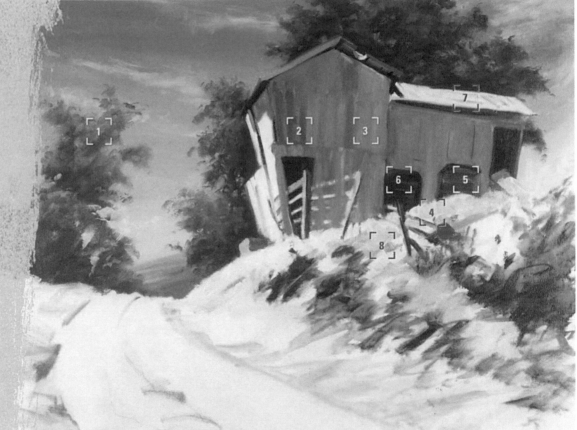

9 ∧ CONTINUE DEVELOPING THE MIDDLE PLANE

Introduce a few slightly lighter color variations into the trees to describe their form, and develop leafy textures where edges overlap the sky with a variety of small sable and bristle brushes.

The shadow side of the barn needs to be a little darker. Make this adjustment now. Keep the paint fairly thin to serve as a foil for the textures of more thickly painted foreground areas yet to come.

1 add Cadmium Yellow Deep to tree colors
2 add a touch of Transparent Oxide Red for darks
3 various combinations of Prussian Blue, Ultramarine Blue Deep, Permanent Red Violet + white
4 white + Cadmium Yellow Deep + Cadmium Scarlet
5 Transparent Oxide Red + Cadmium Scarlet
6 Transparent Oxide Red + Ultramarine Blue Deep
7 white + Cadmium Yellow Deep + a touch of Cadmium Scarlet
8 add a touch of Viridian to grass color

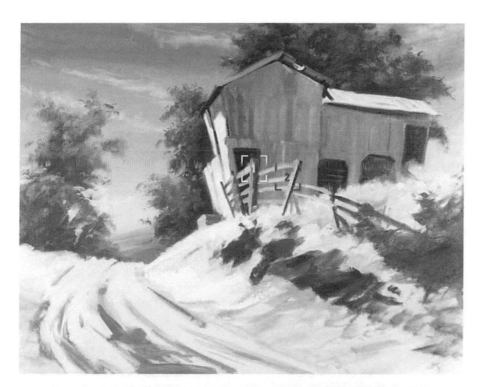

10 < MOVING FORWARD

As you lay in the hillside, feel its rounded form. Paint the dark thistle plants thinly at first with broad, loose brushstrokes, leaving visible patches of underpainting.

Paint the horizontal fence boards with smaller bristle and sable brushes first, and then the vertical posts next because the boards are behind the posts.

Lay in the first directional lines of the road thinly so you can simply wipe them off with a rag moistened with turpentine and redraw them if needed.

1 Cobalt Blue Light + Transparent Oxide Red
2 Permanent Red Violet and Ultramarine Blue Deep + a touch of Transparent Oxide Red + white

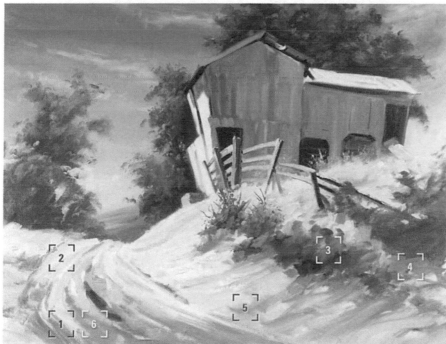

11 < BRING THE WHOLE FORE-GROUND ALONG TOGETHER

Paint the rutty texture of the road with transparent washes, following with alternate brush and knife strokes, and then move on. Develop the more important right side foreground before completing the road. Begin the thistle plants by drawing vertical stems with the rigger. Then paint small leaflike strokes with random hard and soft edges using smaller brushes. Paint the more distant thistles overlapping the barn with the tip of the no. 6 rigger brush. Squiggle on a few strokes of lighter yellow-green to convey a little sunlight.

1 Cadmium Scarlet + Raw Sienna + white
2 white + Cadmium Yellow Deep + Cadmium Scarlet + a touch of Transparent Oxide Red
3 various combinations of Viridian, Raw Sienna, Cadmium Yellow Deep – no white
4 Permanent Red Violet + Cobalt Blue Light + Transparent Oxide Red + white
5 Transparent Oxide Red + Cadmium Scarlet
6 Prussian Blue + Ultramarine Blue Deep + a touch of Transparent Oxide Red + white

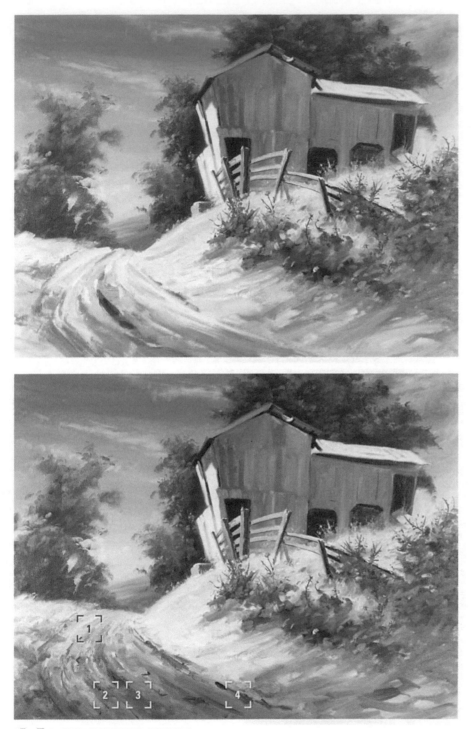

12 < DEVELOP THE THISTLES

Paint the remaining thistles in the same manner as steps 10 and 11—long vertical stems with the rigger first, followed by loosely rendered spiky lower leaves with smaller brushes. Use a variety of greens and, again, retain some of the warm underpainting. Keep most edges hard where stems and leaves overlap the lighter sunlit grass, but soften edges in the lower right of the thistle patch. This will help draw the viewer into the painting and toward the fence and barn.

13 < FINISH THE ROAD

In order to convey the feeling of a well traveled dirt road, develop some quite pronounced textures. Because this is a secondary part of the painting, keep the colors less intense and the overall values closer together than the hill, fence and barn. Break a variety of warm grays onto the curve of the road with a no. 6 flat bristle brush, used flat and on edge. Give the road a few strokes of thick paint with the painting knife. Soften the distant end of the road where it gently wraps over the hill and disappears.

1 white + Permanent Red Violet +
 Ultramarine Blue Deep
2 Ultramarine Blue Deep + Permanent Red Violet +
 white
3 Permanent Red Violet + Ultramarine Blue Deep +
 Transparent Oxide Red
4 Cobalt Blue Light + Transparent Oxide Red

14 > ADD FINISHING DETAILS

Use a small round sable brush to paint the thistle flowers with Permanent Red Violet and a bit of white. Make distant flowers smaller than near ones. No one can tell you how much detail is enough. As a general principle, keep most of the refining brushstrokes and details in the parts of the painting where you want the viewer to dwell; soften and de-emphasize less important areas. Then sign your name.

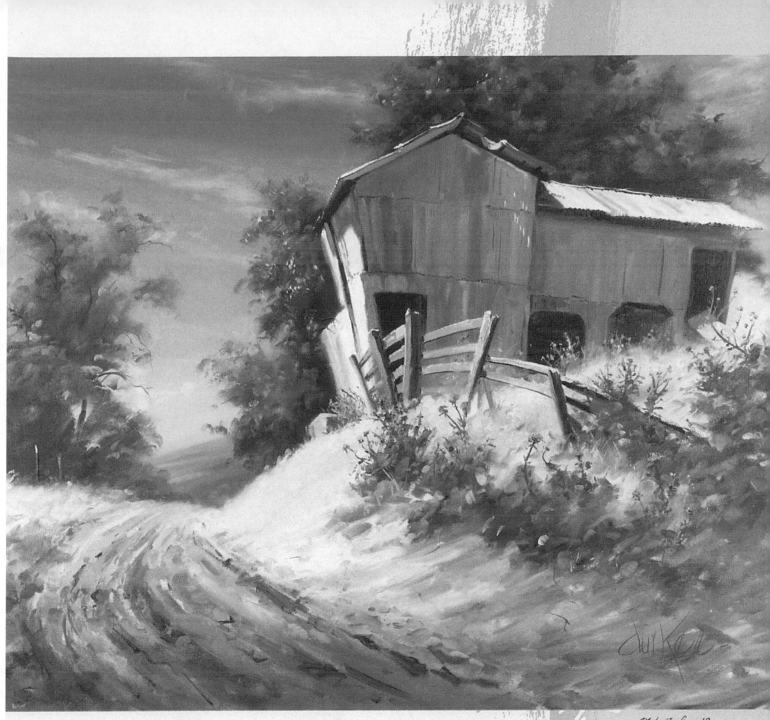

Old Jake's Barn
oil on canvas
24" × 30" (61cm × 76cm)

Let's Review

A thinly applied, transparent monochrome underpainting allows you to work out a strong pattern of values and determine where to use hard and soft edges before addressing questions of color. As you develop the painting in color, major values and edges are predetermined. By allowing some of the underpainting to show through to the finished painting, a subtle color harmony is achieved. Painting with thin transparent washes, followed by layers of thicker pigment applied in a variety of ways, is the essence of advanced oil painting.

balance your intention with your intuition

Materials list

PIGMENTS

Cadmium Yellow Lemon

Cadmium Yellow Deep

Yellow Ochre Light

Raw Sienna

Transparent Oxide Red

Terra Rosa

Permanent Red Violet
 (or Alizarin Crimson)

Ultramarine Blue Deep

Cobalt Blue Light

Viridian

Titanium White

BRUSHES

a selection of small, medium
 and large brushes (see page 14)

TOOLS

painting knife

rag

mineral spirits or turpentine

After completing a few thumbnail pencil studies, you have a destination—a clear intention. What actually takes place on the canvas, however, will be revealed in the process of painting. Even after all of your careful planning, you will make many decisions intuitively. This particular painting has never been painted before; there is no precedent, so you get to make things up. Paintings seldom turn out the way you think they will. Balancing intention with intuition is going/ into the unknown while taking along what you know.

As you paint, let a part of you stand back and observe without judgment. Let go of expectations. There may be a stage of chaos where the canvas looks nothing like the subject you are painting, and you may think, This is not going to work. Lock up the inner critic; it is active when you experience feelings of fear, anxiety or disappointment. Forget about ending up with a masterpiece and focus on the work at hand. As you proceed, you may have no idea how to get from here to there. Nevertheless, you have to jump off the cliff, allowing the free fall where something new can come out of the process. Keep painting. You cannot step back from the edge and do something new. Your intention is your parachute. At some point you'll say, "Oh! This actually works!"

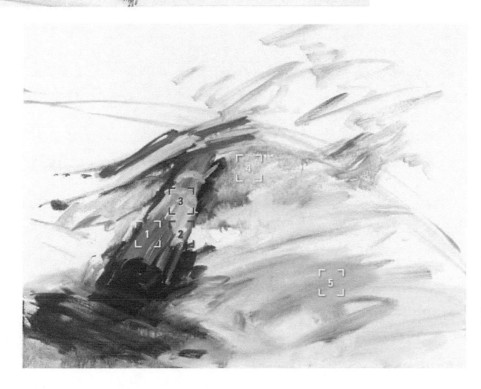

1 ∧ COMPLETE A FEW THUMBNAIL SKETCHES

Determine what you want the painting to express. What is most important and what is less important?

2 < LOCATE THE MAIN SHAPES

After toning the canvas, locate the main shapes with a large flat bristle—two fallen logs, a landmass, and the area to be occupied by a leafy tree, which will overlap the distant plane. Keep the paint thin during this stage. A few simple brushstrokes are enough. Wipe off and redo until you are satisfied. Think shapes (both positive and negative), not logs, land and tree.

1 Transparent Oxide Red
2 Cobalt Blue Light + Transparent Oxide Red
3 Raw Sienna + Cadmium Yellow Deep
4 Viridian + Raw Sienna

3 < ESTABLISH REFERENCE VALUES

Continuing with thin paint and a large brush, capture the light and shadow pattern across the land mass and over the log with light and dark values and a few incremental halftones. Cast shadows follow the form onto which they fall. Although the logs are the intended center of interest, just get them started and move on. You'll develop them as you go, keeping their refinement a little in advance of other parts.

1 Cobalt Blue Light + Transparent Oxide Red
2 Cadmium Yellow Deep + white to previously mixed Cobalt Blue Light + Transparent Oxide Red
3 Permanent Red Violet + Ultramarine Blue Deep + Transparent Oxide Red
4 Transparent Oxide Red + Cobalt Blue Light
5 Ultramarine Blue Deep + Transparent Oxide Red

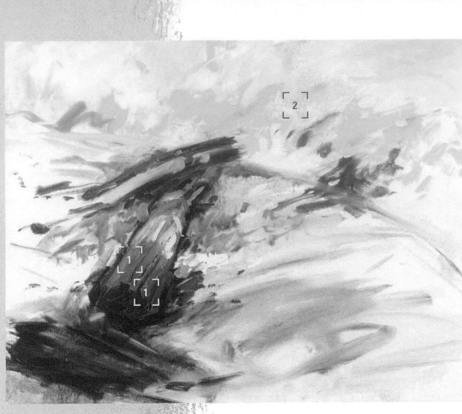

4 < WORK FAR TO NEAR

You'll want to get the large tree in place early on so you can verify the composition, but first paint the distant plane. If you can see the ridges of the brushstrokes in the distant areas, which will be overpainted with the tree mass, scrape some of the paint off with the painting knife so you have only a moderate paint layer that can be easily covered.

1 Permanent Red Violet + Ultramarine Blue Deep
 + a touch of Transparent Oxide Red + white
2 Cadmium Yellow Lemon + a touch of Viridian
 + white

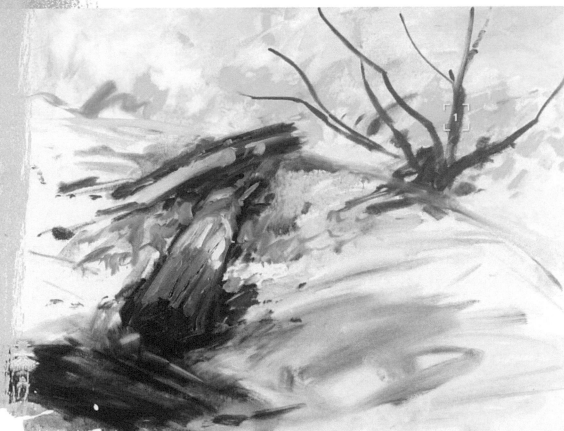

5 ^ DRAW WITH THE BRUSH

Use a no. 6 flat bristle on its edge to draw the tree skeleton. This framework will help you correctly locate masses of foliage. Take a practice swing in the air before painting a brushstroke. Avoid heavy build up of pigment; some of this will soon be painted over.

1 Cobalt Blue Light + Transparent Oxide Red

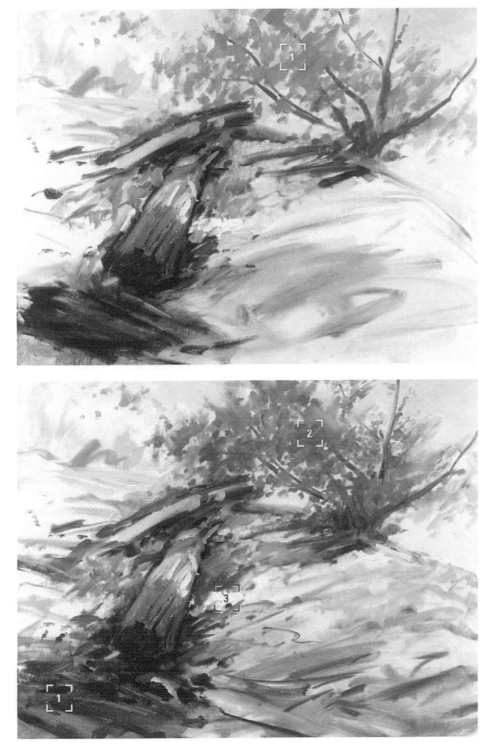

6 < BUILD THE TREE FOLIAGE

Build the tree foliage with a medium size flat bristle—think large masses. Use one color mixture only and get color and value differences by brushing into the background color. Leave plenty of background color showing through. Use soft edges around the periphery. You'll work darker values over this tree foundation.

1 Viridian + Raw Sienna + Cadmium Yellow Deep

7 < YOU DON'T NEED TO BE PERFECT

Now brush a slightly darker pigment mixture over and into the tree allowing the two layers to mix together a little. Avoid rubbing and scrubbing with the brush, trying to make the perfect tree. What may look inept at this stage will often work just fine after more of the painting is painted. Develop smaller leaf patterns, especially at the edges of tree shapes, and come back to the tree later.

Get the foreground started with a few random transparent washes, followed by some semitransparent and opaque brushstrokes.

1 Ultramarine Blue Deep + Transparent Oxide Red
2 Viridian + Cadmium Yellow Deep + Transparent Oxide Red
3 Cadmium Yellow Deep + white

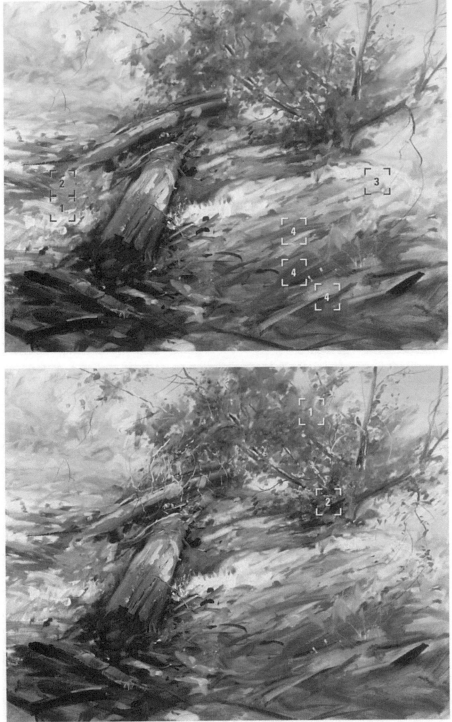

8 < LAYER THE FOREGROUND

Texture and thick paint are not necessarily the same. Build thin layer over thin layer with a variety of brush sizes. Then, achieve contrasting impact with a few thoughtful strokes of thick paint with a knife and brush. Use a few cool colors to indicate reflected light from the sky. Details now come into play, but keep most of the foreground unrefined to allow greater emphasis in the more important middle distance.

1 Terra Rosa + white
2 Permanent Red Violet+ Ultramarine Blue Deep + white
3 Yellow Ochre Light + white
4 Various combinations of Cobalt Blue Light, Ultramarine Blue Deep and Transparent Oxide Red

9 < BACK TO THE TREE

Build more leaf patterns into the tree with darker and lighter variations of green and some cool blue sky reflections, using the smaller bristle brushes and a small round sable brush. Paint the slightest limbs with the rigger brush, and tie the tree and distant log together with some fine sunlit limbs.

The composition can be improved by extending the tree farther to the left. The distant upper left needs more interest.

1 Cobalt Blue Light + white
2 Viridian + white

10 > ADD FINISHING DETAILS

For the upper left distance beyond the tree, use high-key values (see page 43) and keep the color cool. Be sure the horizon line is a soft edge. Suggest leaf patterns rather than painting each single leaf as you extend the tree. Now the composition works, so stop painting and sign your name.

Two Logs and a Bush
oil on canvas
24" × 30" (61cm × 76cm)

Let's Review

You won't know what the final painting will look like until you paint it.
Your plan, or intention, is simply a place to begin. As you develop your
painting, strike a balance between conscious reasoning and instinct.
There may be stages when you don't know whether the painting
is working or not, but keep going. Trust the process.

walk in swinging

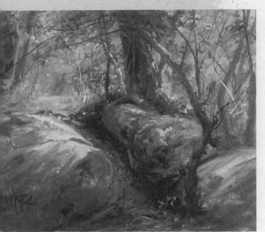

Materials list

PIGMENTS

Cadmium Yellow Lemon

Cadmium Yellow Light

Cadmium Yellow Deep

Raw Sienna

Transparent Oxide Red

Cadmium Scarlet

Cadmium Red Deep

Permanent Red Violet
 (or Alizarin Crimson)

Ultramarine Blue Deep

Cobalt Blue Light

Prussian Blue

Viridian

Titanium White

BRUSHES

a selection of small, medium
 and large brushes (see page 14)

TOOLS

painting knife

rag

mineral spirits or turpentine

Because your notion of what makes a good composition, your color sense, and even the way you hold your brush are unique, don't adhere too closely to the way I've painted this demonstration. True, all of the demonstrations are presented as though I am standing next to you saying, Do this, and now this and then follow with this. However, your sensibilities are different than mine, so make your own creative choices. Approach the demonstration in a spirit of play. While one part of you thinks about technical principles—light/dark, warm/cool, lines/angles, pigment mixtures and which tools to use—let the other part of you, the wordless part, feel its way along. Many effects will come about by accident. You will discover painting tricks I may not show you. Textures, color juxtapositions and compositional possibilities will emerge as if by magic. Remember these and learn to apply them deliberately.

This high-risk way of painting is not for the timid who need everything figured out in advance. The chances of failure are greater than with other ways of painting, but so are the chances of improving your skills and discovering new and original techniques—learning something new by doing something different. Try painting in this fashion to take yourself a step beyond the boundary of your own knowing.

Painting in the manner shown, there is no difference between drawing and painting. Composition, color and texture are all worked out on the canvas in one organic process. Instead of starting with lines or shapes on the canvas to guide the application of color (as in some of the previous demonstrations) you will simply draw with the brush as you go. As a regular practice, it is best to have some way to visualize your composition in advance. You could do a few thumbnail pencil studies first, but sometimes it can be instructive to simply walk in swinging.

1 < ESTABLISH ASYMMETRY

Use a no. 10 flat bristle to begin composing the painting directly on the canvas. Divide the foreground and distance into unequal halves with a rhythmic horizontal line. Give this line two hills and two valleys—the highest hill just to the right of center and the smaller one far to the left (see "Asymmetry" on page 58). This important line of your composition sets up an asymmetrical balance.

1 Prussian Blue + Transparent Oxide Red

2 < TONE THE CANVAS

Lay a warm, transparent wash above the line using a no. 10 or no. 12 flat bristle, then brush on a few darker strokes of the same color. Dab it a few times with a rag to begin a random pattern in the distant plane. This is underpainting. Now, with the same color as the rhythmic line, tone the lower half of the canvas to lower the value from stark white.

1 Transparent Oxide Red + Cobalt Blue Light

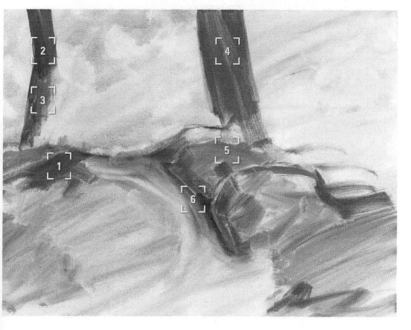

3 < THINK COMPOSITION

Place a tree trunk to the right of the center and a more slender one far to the left with the no. 10 flat bristle. Vary the sizes and shapes of the big rocks in the foreground. The composition flows from the lower right, up to the left and between the two trees (see "Flow" on page 58). Improve the arrangement by nudging objects this way and that.

1 Viridian + Raw Sienna
2 Ultramarine Blue Deep + Transparent Oxide Red
3 Transparent Oxide Red + Cadmium Scarlet + white
4 Viridian + Transparent Oxide Red + a little Cadmium Yellow Deep
5 Cobalt Blue Light + Transparent Oxide Red
6 Transparent Oxide Red

4 < PAINT BROAD PATTERNS OF COLOR

Begin building a loose pattern of brushwork in the distant forest beyond the tree trunks, striving for varied textures. Brush one color into and over another, allowing some of the first layer to show through. Cool color variations will predominate in this distant plane, but its okay to use a few warmer combinations in the first lay in.

1 Raw Sienna + Viridian
2 Viridian + Cadmium Yellow Lemon + white
3 Cadmium Yellow Lemon + a touch of Viridian + white
4 Viridian + Prussian Blue
5 Permanent Red Violet + Cobalt Blue Light + a touch of Transparent Oxide Red + a touch of white

MUSINGS | *While painting at my growing edge, there is a magnetic pull to revert to a less challenging subject. I feel the urge to mix colors and manipulate pigment in familiar and comfortable ways. Or to simply run away. How many times have I crossed the boundary of my own knowing, only to pull back?*

5 ^ BUILD LAYER OVER LAYER

Create an array of shapes and colors with thin and thick layers of pigment. Then, place more tree trunks and branches with a variety of brushes. Vary the width, angles and spaces between tree trunks. When painting fine lines with the long-haired rigger, thin the paint so it almost flows, and then load the entire length of the brush hair. Paint wet-into-wet—one stroke; wipe the brush on a rag, reload and make the next stroke.

1 Ultramarine Blue Deep + Transparent Oxide Red
2 Cobalt Blue Light + Transparent Oxide Red
3 Viridian + Transparent Oxide Red
4 Prussian Blue + white
5 Viridian + white
6 underpainting shows through
7 Viridian + Transparent Oxide Red
8 Cobalt Blue Light + Transparent Oxide Red
9 Transparent Oxide Red + Ultramarine Blue Deep
10 build layer over layer

6 > DEVELOP THE FOREGROUND

Build the rocks on the right using a range of bristle brushes and heavy layers of paint, but leave some of the transparent underpainting showing through for more textural interest. Contrast with heavy knife strokes. Paint the large sunlit rock in the left foreground, first with a brush and then with a knife.

The composition has a feeling of viewing the scene from a distance, so look about to find an intriguing tree shape to transplant into the foreground.

1. white + Cadmium Yellow Deep + a touch of Cadmium Scarlet
2. Prussian Blue + white
3. Permanent Red Violet + Ultramarine Blue Deep + white
4. Cadmium Red Deep + Permanent Red Violet + white
5. Cadmium Yellow Light + a touch of Viridian
6. Viridian + Cadmium Yellow Light + a touch of Transparent Oxide Red
7. underpainting shows through

7 < AND NOW, THE SCARY PART

With a small, clean, dry brush on its edge, draw the borrowed tree trunk lightly into the still wet painting surface to verify the placement, and then paint it in.

Complete the more distant plane first before painting the overlapping branches of the foreground tree. Use more intense color here to draw the viewer beyond the foreground and into the painting.

8 < KEEP THE FOREGROUND SIMPLE

With small and medium flat bristle brushes, build some textures into the path and rocky foreground, layer over layer. Use variations of warm and cool grays to indicate the damp forest floor. Suggest rather than define the foreground rocks to keep them from drawing too much attention from the more important middle distance part of the painting.

1 various combinations of Ultramarine Blue Deep, Cobalt Blue Light and Transparent Oxide Red

9 < COMPLETE THE FOREGROUND TREE

Now draw the arching limbs of the foreground tree with the rigger. Look ahead of where the brush touches down and the line will follow your eyes. Borrow leaf patterns from other trees to fit the composition if needed.

Now ask, *What does the painting want?* The foreground has to go because it detracts from the more important middle distance.

1 various combinations of Viridian, Transparent Oxide Red and Cadmium Yellow Deep

10 > MAKE FINAL CORRECTIONS

You may resist, but scrape off and repaint the foreground (if it doesn't work, it has to go). Invite the viewer to venture into the distant forest with a few strokes of intense yellow-green.

How much detail? You could persevere for days longer in an effort to give the painting more refinement, but some of its spontaneity would surely be lost.

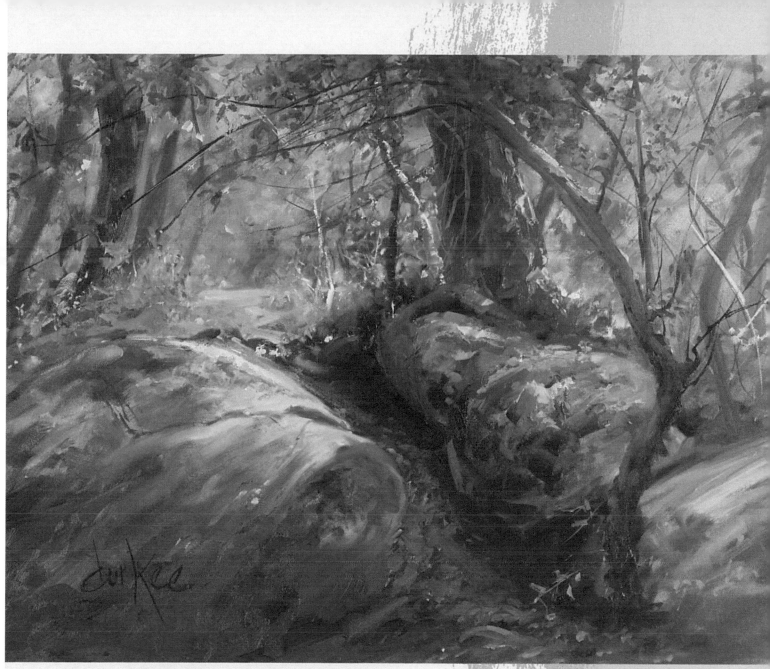

Forest Entry
oil on canvas
18" × 24" (46cm × 61cm)

Let's Review

Design and paint the painting at the same time. When you stumble upon a happy accident, review how it came about and then add it to your catalog of painting techniques. Don't just copy, create. Push your tools and materials to the limit to find out what they will and will not do. No one can show you how to do this; you have to do it for yourself.

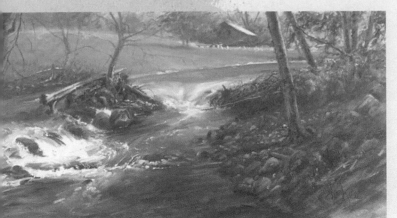

simplify a complex subject

Materials list

PIGMENTS

Cadmium Yellow Light

Cadmium Yellow Deep

Yellow Ochre Light

Raw Sienna

Transparent Oxide Red

Terra Rosa

Permanent Red Violet
 (or Alizarin Crimson)

Ultramarine Blue Deep

Cobalt Blue Light

Viridian

Titanium White

BRUSHES

a selection of small, medium
 and large brushes (see page 14)

TOOLS

painting knife

rag

mineral spirits or turpentine

Imagine you are in nature, ready to begin your next painting. Because painting is capturing emotions as much as it is recording the physical appearance of a place, it is important to stop all activity and be with your surroundings. Can you identify what draws you into the landscape? Rather than strategizing and planning your painting, take time to get acquainted. Just as your eyes are the window to your soul, find the way into the soul of your subject. Where is the eye contact with your landscape? What is most important to you? As you learn what is essential to this place, it will begin to assume more prominence in your mind's eye. What is not essential will fall away.

Now, with a pencil and sketchpad, think about how you will translate the visual elements of the scene onto your canvas. This demonstration explains one way an intricate landscape can be seen as a few simple shapes. By dividing the subject into three broad shapes and visualizing them as discrete value keys, the complex subject becomes less daunting. (See "Value Keys" on page 43.) Let's say you have decided that the stream with its island of outcropping of rocks is the eye contact of your subject; make it the largest shape with the strongest contrast of values. Think of the distant plane as a single shape, appearing and disappearing behind overlapping tree trunks. Paint it with middle to high-key values so that it recedes into the distance. Make the shape of the right side landmass smaller than the stream shape and paint it predominantly with middle dark values because it is less important than the full value range of the stream and island.

Every landscape presents a different puzzle to decipher. Be still. Look for your subject's broadest, most simplified components. Squint your eyes to indentify the main shapes. How you see the lay of the land, the light changing over time, the time available before the light changes, and even your particular whim, will vary from one painting to the next. On another day you will conceive your painting in a different way. You will never step into the same stream twice.

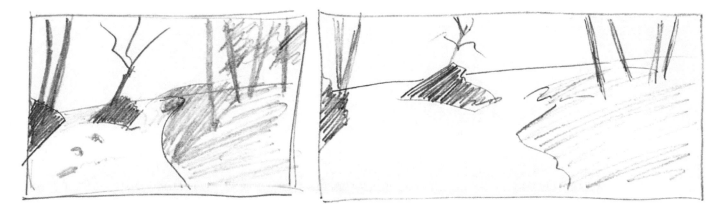

1 ∧ THINK LARGE SHAPES

If the shapes in the actual subject are uninterestingly distributed from side to side and top to bottom as they are in the first example, reproportion them for a better design. As you paint, subdivide the large shapes into smaller ones. But throughout the painting process, continue to think of the large shapes as the main components of the composition.

2 < ESTABLISH THE MAIN SHAPES

After toning the canvas, divide the picture area with a diagonal line above the center with a no. 4 flat bristle brush on edge. Locate the right side landmass with a second line to the right of center and you have three pleasingly varied main shapes. The area of the stream, which is most important, is the largest.

1 Raw Sienna + Cobalt Blue Light

3 < LOCATE THE ISLAND AND TREE

Locate the island and fallen log, then draw the tree trunk growing upward from the island about one-third of the way across the canvas. Now, place more tree trunks, being careful to vary the distances between them, and also the distances to the picture borders.

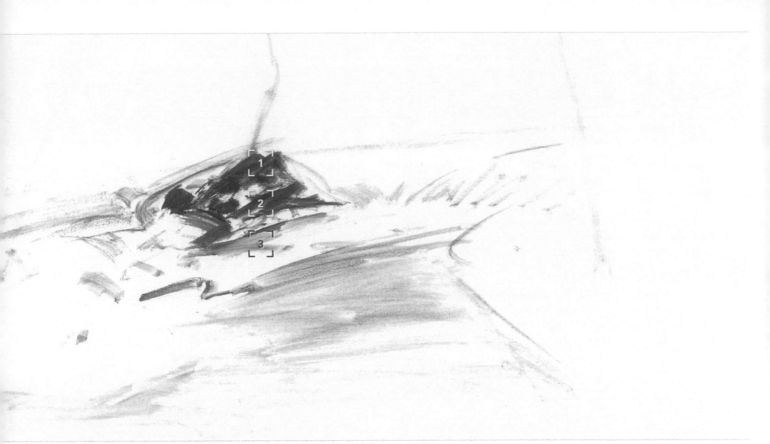

4 ∧ PAINT THE MOST IMPORTANT PART FIRST

Because the water and outcropping of rocks is the most important of the three main shapes, paint this part of your painting to near completion first with a full range of values. Study the water and rocky island to find their most simplified subdivisions of values and begin them with transparent brushstrokes. Use a no. 10 or no. 12 flat bristle brush, thinning the paint with turpentine or mineral spirits so you can easily wipe off or paint over, modifying shapes as needed.

1 Cobalt Blue Light + Transparent Oxide Red
2 Permanent Red Violet + Ultramarine Blue Deep
3 Viridian + Cadmium Yellow Deep

5 > ESTABLISH REFERENCE VALUES

With a full range of values, paint the island and some adjacent foamy water, and use this area as the reference values. This will help you to accurately gauge the values of the water. Later on, you will find it easy to paint the distant plane in middle to high-key values and the right side landmass in a middle dark value key by comparing them to these reference values.

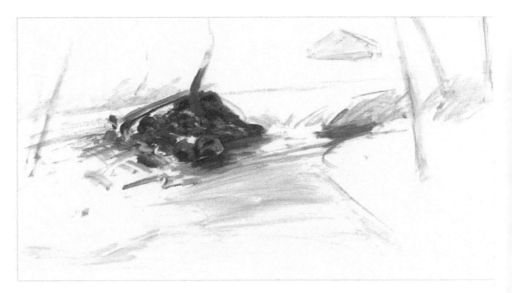

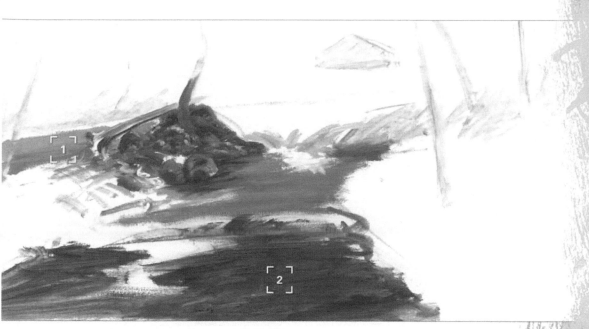

MUSINGS | *The idea that inspiration flows down the arm, through the fingers into the brush and somehow the right color lands in the right place is a myth. Sometimes painting is the carefully deliberate application of known principles, and at other times it is taking risks without knowing what the outcome will be. It is never an accident—unless it is.*

6 ∧ LOOK FOR THE LARGE WATER SHAPES

Although the water is in constant motion, it is made up of shapes that are relatively stable within themselves. Study the water to find these shapes. Lay in the dark parts of the water first with thin paint and a large bristle brush; then, paint the middle dark values.

1. Cobalt Blue Light + Raw Sienna
2. Viridian + Transparent Oxide Red

7 ∧ CONTINUE DEVELOPING THE WATER

Water is the color of what you see through it or the color of what it reflects. Moving water, after becoming aerated from flowing over rocks, takes on its own color. Paint rocks in the stream; feel how the water flows over and around these obstructions. Water dances and changes, but the same or similar shapes recur again and again. Instead of trying to paint water, let the brushstrokes mimic these shapes.

1. Raw Sienna + Cobalt Blue Light + Cadmium Yellow Deep

8 ∧ DON'T USE PURE WHITE FOR FOAM

Pure white foam would appear chalky and colorless. Place a generous amount of white onto a clean area of the palette. Alter the white by mixing into it a very small amount of a lighter, warmer combination that you have previously used for another part of the water, lowering the value of the white only a step or so. Now, lay this mixture onto the main white water parts of your painting with a painting knife for a heavy impasto layer of paint. Use small and medium size bristle brushes to paint smaller patches of white water. Don't try too hard to make it look like water at this stage; just get the paint onto the canvas.

1 white + Raw Sienna + Cobalt Blue Light

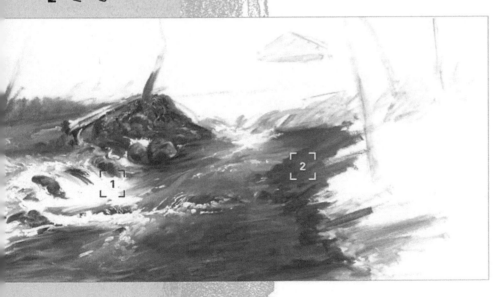

9 < LOOK BEFORE YOU PAINT

See how the water rushes downhill, spilling over a steep incline, foaming as it rolls like surf, backward against the current, with a little foam carried farther downstream. Where sunlight strikes the white water, add a very small amount of Cadmium Yellow Deep to pure white. While the paint is still wet, begin the left and right shorelines to avoid hard edges later that would feel like paper cutouts.

1 white + Cadmium Yellow Deep
2 Cobalt Blue Light + Transparent Oxide Red

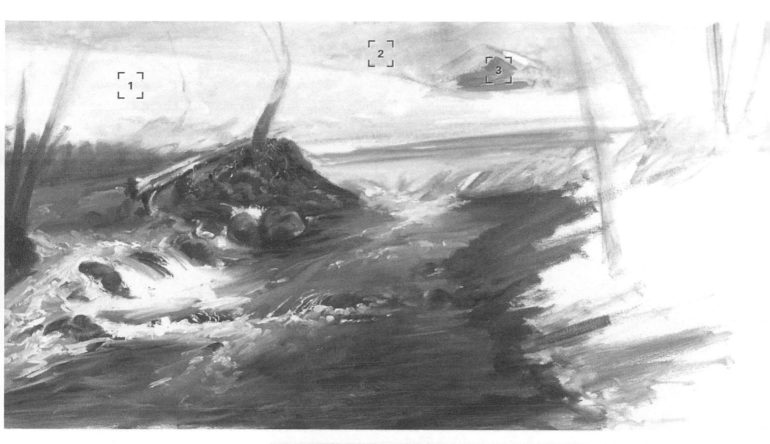

10 ^ BEGIN THE DISTANT PLANE

Moving to the distant plane next, begin with transparent washes for underpainting, which you may want to show through to the finished painting. Now, place a new set of reference values to establish the middle to high-key range of values within which you will work as you develop the distant plane.

1 Yellow Ochre Light + Transparent Oxide Red
2 Cobalt Blue Light + Transparent Oxide Red
3 Terra Rosa + Cobalt Blue Light

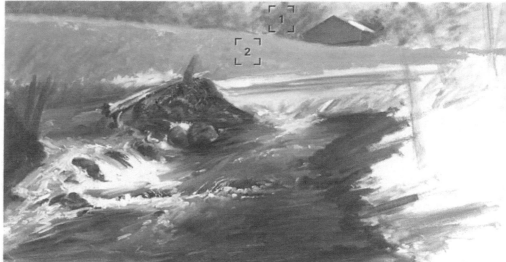

11 ^ COVER THE DISTANT CANVAS

Temporarily thinking of the distant plane as an independent painting, lay in the green grass and red cabin broadly and simply with large and medium size bristle brushes. Then, carefully scrub unthinned pigment over the far distant underpainting with a small bristle brush to create silhouetted tree shapes.

1 Viridian + Cobalt Blue Light + Transparent Oxide Red
2 Viridian + Cadmium Yellow Light

93

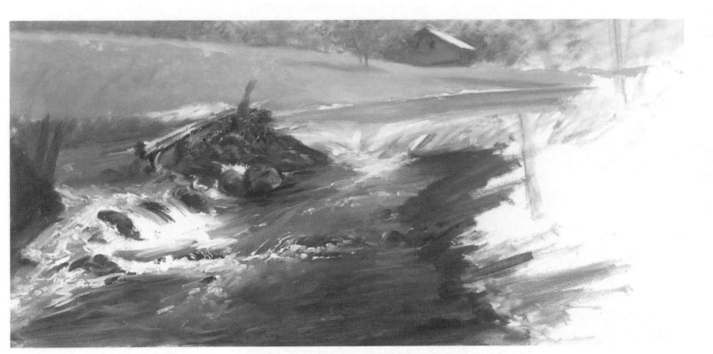

12 ^ REFINE THE DISTANT PLANE

As you develop the cabin and distant tree, it's okay to use a few values that are darker than the overall middle to light value key of the distant plane, but be sure they are not nearly as dark as those in the closer island. Don't overrefine the left side distant trees because they are simply a foil for closer tree limbs, which will overlap this area. Do soften the distant edge of the green grass where it rolls over the hill and disappears.

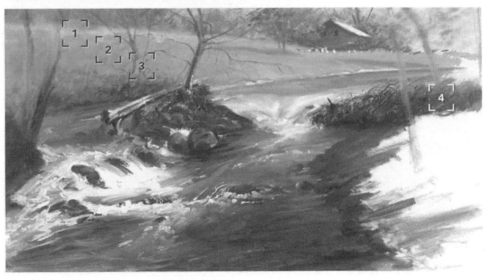

13 ^ BEGIN THE OVERLAPPING TREES

When you are satisfied with the distant plane, paint the tree trunk growing upward from the island with a medium size bristle brush on its edge. Use the rigger to paint smaller branches, painting wet-into-wet with paint thinned until it flows. Wipe the brush between strokes and reload to avoid picking up the underlayer. Make the tree on the far bank a little lighter because it is farther away. Paint the tangled mass of debris to the right of the water first with a transparent wash and then with a small bristle brush and the rigger brush.

1 soften this edge
2 add Cobalt Blue Light + white to grass color
3 make the distant tree lighter
4 underpaint with Cobalt Blue Light + Transparent Oxide Red

94

14 ∧ PAINT MORE TREES

As you paint tree trunks on the right side of the canvas with a medium size bristle brush, look carefully at how reflected light causes variations in value from one tree to the next and from the edge of a tree trunk to its center. To paint the foliage around and behind these trees, hold a long bristle filbert flatwise and loaded with paint, and gently roll it onto the surface of the painting.

1 Raw Sienna + Cobalt Blue Light
2 Viridian + Cobalt Blue Light + Transparent Oxide Red

15 ∧ DEVELOP THE RIGHT SIDE LANDMASS

With a large bristle brush, lay a transparent wash over the entire right side rocky area to give a warm undertone, and then loosely and transparently brush a second darker and warmer layer over this. Now, with a medium size bristle brush begin building rock shapes with cool grays, ignoring patterns of sunlight. Keep the values within the middle dark range as you have planned from the beginning. You will add darker and lighter accents later as needed.

1 Cobalt Blue Light + Terra Rosa
2 Cobalt Blue Light + Transparent Oxide Red + Permanent Red Violet
3 Viridian + Transparent Oxide Red
4 Transparent Oxide Red + Cobalt Blue Light

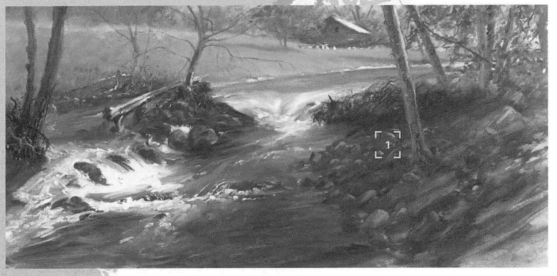

16 ^ REFINE THE ROCKS WITH SUNLIGHT

You don't have to depict every single rock in your subject. Simplify, but do look carefully for patterns of light, shadow and cool reflected light. Make closer rocks larger. Trusting you intuition, build rock patterns that work with the flow of the composition.

1 sunlit rocks are Terra Rosa + Cadmium Yellow Deep

17 > MAKE ADJUSTMENTS AND ADD FINISHING DETAILS

Trust your personal taste and judgment as you further refine the painting. Alter and add to the water and rocky island, the distant plane and right side landmass only if you feel changes will improve the overall design. Details in the actual subject that would distract from the picture idea should be left out.

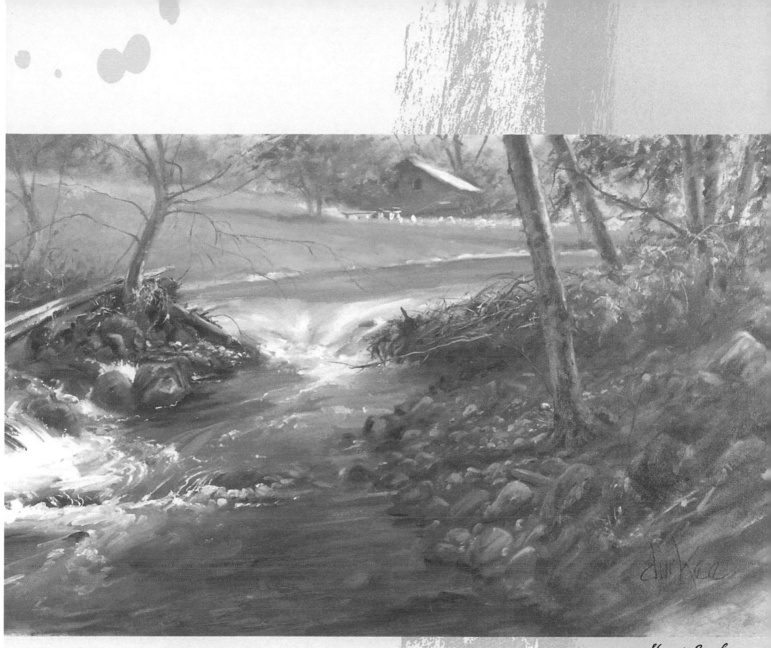

Sharp's Creek
oil on canvas
15" × 30" (38cm × 76cm)

Let's Review

Take time to get to know your landscape before you begin painting. Simplify a complex subject by dividing it into a few broad shapes. You can then develop them concurrently, or you can paint them one at a time to near completion as in this demonstration, always thinking of them as individual parts of the whole. Make a plan for how you will proceed and follow it through to the end.

the mother color

The "ghost tree" in this demonstration emerges from the fog. There is a hush that subdues sound, color and light. Everything becomes quiet; subtle color merges with subtle color. The grays are not black and white, nor are they made pastel by simply adding white paint to color; instead, each color in the painting takes on some of the mother color.

The essence of this demonstration is to achieve color harmony by adding one particular color, called the mother color, in varying amounts to nearly all of the colors in the painting. In this painting, the mother color is the color of dense fog. It will not be obvious in every brushstroke of the painting, but its subtle influence will be felt. When looking through fog or heavy atmosphere, colors become muted but are still discernable.

Become quiet within yourself to perceive the quieter color. To paint honestly, don't stand back, as though you are independent from the subject. Place yourself in the landscape; sharpen your senses to find the essential truth of the subject. In finding a balance between this truth and the process of painting, your emotions and your process will match the mood of the subject. Then you will paint from a place of connectedness.

Materials list

PIGMENTS

Cadmium Yellow Light

Cadmium Yellow Deep

Yellow Ochre Light

Raw Sienna

Transparent Oxide Red

Terra Rosa

Permanent Red Violet
 (or Alizarin Crimson)

Ultramarine Blue Deep

Cobalt Blue Light

Viridian

Titanium White

BRUSHES

a selection of small, medium
 and large brushes (see page 14)

TOOLS

painting knife

rag

mineral spirits or turpentine

1 < FIND INSPIRATION IN YOUR SKETCHBOOK

Now and then a particular drawing will suggest a powerful mood. Try developing it into a full-blown oil painting or even a series of them.

2 < BLOCK IN THE TREE

On a toned canvas, make a line drawing of the tree with a no. 10 flat bristle brush on its edge. Now loosely block in the tree with transparent brushstrokes, thinning the paint with turpentine or mineral spirits. Allow some of the toned canvas to show through.

1 Raw Sienna + Cobalt Blue Light

3 < BEGIN THE BACKGROUND

Lay in the area surrounding the tree generously with a painting knife, filling the interstices of the canvas with a thick layer of paint that will stay wet for an extended period of time. This will allow you to work wet-into-wet to achieve diffused edges hours (or days) from now. This background color—the mother color—represents the color of the air. For parts of the subject that are farther away, you will use greater amounts of this color in the mixtures, creating the illusion of looking through a heavy layer of atmosphere.

1 mother color for this painting: white + Viridian + Permanent Red Violet

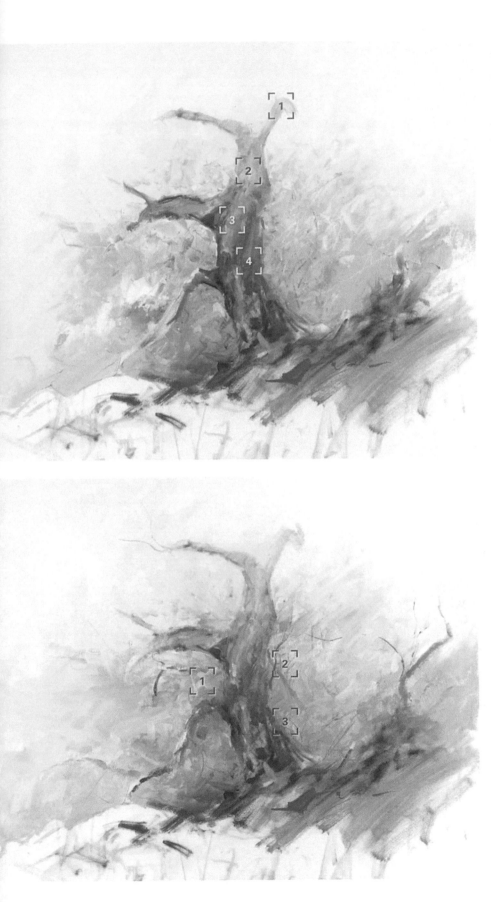

4 < BEGIN DEVELOPING THE TREE

Complete the rest of the background with the painting knife, smoothing peripheral areas a little with a no. 12 flat bristle. Looking for shapes of values in the large tree trunk, carefully build ragged layers of transparent and opaque pigment, one over another with a medium size bristle brush. Mix a small amount of the mother color into these tree colors because you are looking through a layer of atmosphere; add the most to the upper tree trunk because it is farther away. Look through obstructing limbs in the actual subject to find the underlying textures of the tree trunk. Later, you will paint smaller limbs over this. Paint edges softly.

1 pure mother color
2 add mother color
3 add mother color to: Raw Sienna + Cobalt Blue Light + Terra Rosa
4 add mother color to: Viridian + Transparent Oxide Red + Cadmium Yellow Deep

5 < REFINE THE TREE TRUNK

Use smaller brushes to further refine the tree trunk. To help convey an atmospheric effect, soften the edges where the tree interfaces with the surrounding background. Work a little of the warmer trunk colors into the background with the knife and a large brush as a foundation for smaller branches that you will paint later.

1 work in warm colors of the tree trunk
2 darker variation of the mother color
3 soften edges of the tree trunk

6 ∧ PAINT THE FOREGROUND

Lay dark transparent brushstrokes over the foreground area with a large bristle brush. Then, begin painting the rock shapes leading into the composition from the lower left corner. Use darker values and little or no mother color since this area is seen through a thinner layer of air. Now that the canvas is covered, you can easily gauge the values needed for smaller limbs.

1 Ultramarine Blue Deep + Transparent Oxide Red
2 Viridian + Cadmium Yellow Light + Transparent Oxide Red

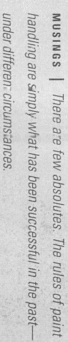

7 > BEGIN PAINTING SMALLER LIMBS

With the no. 10 bristle brush, soften the background grays surrounding the tree to prepare it for overpainting with smaller limbs. In the finished painting, these warm and cool background smudges will be seen through the fog as groups of branches. Now, carefully reading the values of branches and twigs in the actual subject, paint more distant branches with the rigger, adding the mother color for thick atmosphere. Soften these fine lines a little with a small bristle brush and the sable filbert, and then build more branches over them.

1 Terra Rosa

8 < PAINT SOFTLY

Make distant edges softer because you see them through more atmosphere. Softly paint the edges of the tree trunk. Progressively add layers of small twigs and branches with the most complex tangle of branches where you want to draw the most attention. Forego adding the mother color to branches in the area you want to be the most noticeable.

1 build twigs and branches layer over soft layer
2 Yellow Ochre Light + a touch of Cobalt Blue Light + white
3 soft edge
4 Terra Rosa

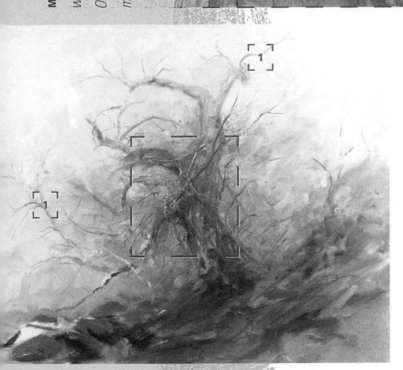

9 < DEVELOP DISTANT BRANCHES WITH MOTHER COLOR

Using a variation of the mother color that is just slightly darker than the background, paint peripheral limbs seen through the fog. Place the limbs into the still wet background with the small bristle brushes and the rigger. Although cylindrical in form, these branches tend to appear as silhouettes when seen through heavy atmosphere. So don't be overly concerned about defining light effects on them. Now, soften the more distant branches with the sable filbert.

1 soften with a sable filbert

10 > COMPLETE THE FOREGROUND

Paint the rocks simply in the lower left of the painting with a medium size bristle brush. Retain the dark values here to help serve as a lead-in for the composition. But don't overdevelop the rocks with texture and detail because they would then compete with the tree. Add more of the mother color as they recede into the painting.

Ghost Oak
oil on canvas
24" × 30" (61cm × 76cm)

Let's Review

Working with the mother color is a reliable way to achieve color harmony in your paintings. When combined with exaggerated soft edges, strong moods with atmospheric effects are easy to accomplish. It is not always necessary to add the mother color to every single color in a painting; you can make the focal area speak louder by deviating from the predominant color key.

five ways to convey distance

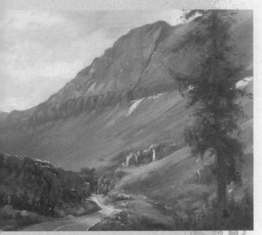

Materials list

PIGMENTS

Cadmium Yellow Lemon

Cadmium Yellow Deep

Transparent Oxide Red

Cadmium Scarlet

Terra Rosa

Permanent Red Violet
 (or Alizarin Crimson)

Ultramarine Blue Deep

Cobalt Blue Light

Prussian Blue

Viridian

Titanium White

BRUSHES

a selection of small, medium
 and large brushes (see page 14)

TOOLS

painting knife

rag

mineral spirits or turpentine

When viewers say, "I feel like I could walk right into your picture," they are responding to as many as five graphic devices you have employed to draw them irresistibly into your work. This demonstration shows you all five of them:

1 *Linear perspective makes objects become smaller as they recede into the distance.*

2 *Overlapping causes objects behind others to appear farther away.*

3 *Aerial perspective makes distant colors appear lighter, cooler and less intense, and light colors to become a little darker.*

4 *Near textures are more pronounced than those farther away.*

5 *Edges become softer with distance.*

You can use some or all of the five devices to convey depth in your paintings whether the distance you want to evoke is ten inches or ten miles.

Dialogue with the landscape. When engaged in a stimulating conversation, first you listen, and then you speak. When painting, you see and then you paint. Look at your subject. Read the hue, value and intensity of a color as they relate to near, middle and distant planes of your scene and mix the color on the palette. Look at your subject again to understand the shape of the area to be painted and then begin painting the shape. Look at your subject. Paint more of the shape. Look again. Spend as much time looking as you do painting. Look . . . and then look again.

As you study your subject, the five ways to communicate depth will give you clues about what to look for. Use this visual information to convey distance.

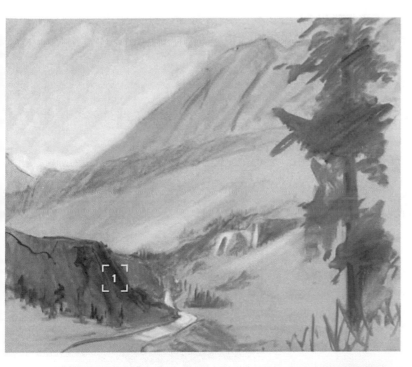

1 < BLOCK IN THE MAIN SHAPES WITH FOUR VALUES

Having planned the painting with a few thumbnail sketches, compose carefully on the canvas. Begin with a line drawing to locate the main shapes. Then, block in the dark, middle dark, middle light and light values with a no. 10 flat bristle. The blue tone of the canvas suggests the chilly mountain air of the high country. Wipe off and redraw if you need to. This large, complex painting will take a few days to complete, so take the necessary time to lay a good foundation.

1 Ultramarine Blue Deep + Prussian Blue
 (crosses blue primary line, resulting in a grayed blue)

2 < PAINT THE MIDDLE DISTANCE FIRST

As you lay in the two overlapping ledges of rock on the left, make the more distant one a little lighter and more blue because it is farther away. Paint the rocky outcropping on the right side of the road somewhat lighter on its shadow side because it is even farther away. Compare values in the actual subject and be careful to get the correct value relationships on the canvas from the very beginning. These dark, middle and light values are the first of your reference values.

1 Ultramarine Blue Deep + Prussian Blue + Terra Rosa
2 add Cobalt Blue Light + white to the previously mixed
 Ultramarine Blue Deep + Prussian Blue + Terra Rosa
3 Ultramarine Blue Deep + Viridian
4 Cobalt Blue Light + Terra Rosa

3 < CONTINUE LAYING IN THE FOCAL AREA

Paint the strong linear perspective of the road with the smaller bristle brushes. Add a few middle-value greens in the focal area to get a full set of reference values. As the painting develops, you will paint darker shadows in the foreground and lighter shadows in the distant mountains, exaggerating the aerial perspective of the painting. Keep your development broad and simple at this stage.

1 white + Cadmium Yellow Deep + Cadmium Scarlet
2 add Cobalt Blue Light + white to the previously mixed Cadmium Yellow
 Deep + Cadmium Scarlet
3 white + Cadmium Yellow Deep + Cadmium Scarlet
4 Cadmium Yellow Lemon + Prussian Blue

4 < PAINT BEYOND THE FOCAL AREA

Extend the lay-in to include the more distant greens and the cool slanting plane beyond. This will help you determine how much detail the focal area needs. Keep most of the focal area shadows in the middle of the value scale. Don't paint behind the large tree on the right just yet because when you paint the tree on another day, you'll want wet paint to work into.

1 Cobalt Blue Light + Terra Rosa
2 Cadmium Yellow Deep + Prussian Blue

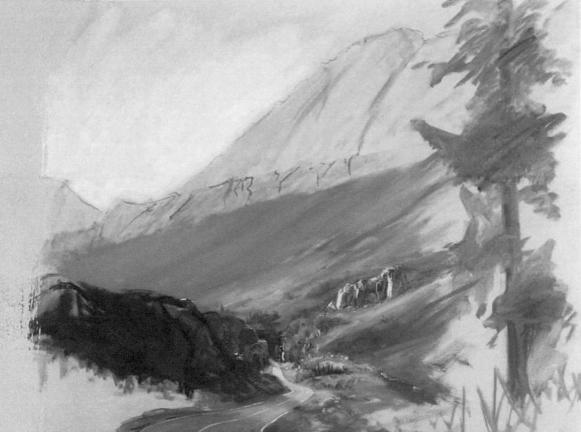

5 ^ BEGIN DEVELOPING DETAIL

In demonstration one, you covered the entire canvas before adding any detail. Here, because of the length of time it will take to paint each part of the composition, develop detail in the focal area while the light holds and the paint is still wet. This will allow you to make soft edges where needed. Working in this complex area with the smaller brushes, you may feel like you are racing the sun, but slow down and paint as accurately as you can. When the light changes on this part of the scene, stop painting for the day.

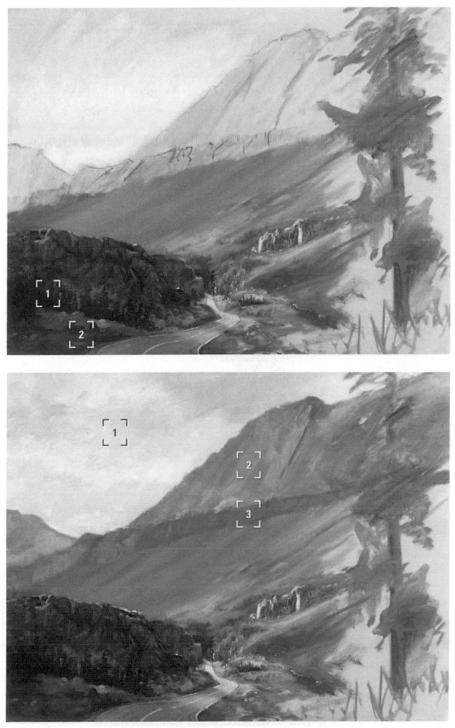

6 < MAKE THE FOREGROUND DARK

Day two. Before you begin, reconnect with the immense distance you have set out to convey. Because dark values become lighter and cooler with distance, make the foreground darker and warmer than the more distant areas you painted yesterday. Avoid a "picket fence look" in the row of trees in front of the big rock on the left by spacing them unevenly. Although closer textures are more apparent, understate them for now. When the entire canvas is covered, you can better judge how much texture the foreground needs.

1 Ultramarine Blue Deep + Cadmium Yellow Deep + Transparent Oxide Red
2 Viridian + Transparent Oxide Red + Cadmium Yellow Deep

7 < LAY IN THE DISTANT MOUNTAINS AND SKY

Underpainting the distant mountains, scrub the paint onto the canvas with a medium size bristle brush using values that are halfway between the darkest and lightest ones you see there. Although rocks in the near, middle and distant planes are all made of the same material, make dark colors lighter and cooler in the distant plane. Because the sky radiates diffused light from the sun, paint it with warmish grays. Paint cloud edges very softly, wiping the no. 12 bristle frequently on a clean, dry paint rag.

1 white + Viridian + Permanent Red Violet
2 Cobalt Blue Light + Terra Rosa
3 Ultramarine Blue Deep + Prussian Blue

8 < REFINE THE MOUNTAIN

Paint the air! Use high-key values, cool color combinations and a smooth paint layer. Textures are lost at this great distance. Light values are not as light as those in the middle distance. Working lighter and darker values over the first underpainting, define the craggy mountain with the smallest bristle and sable brushes and then soften all edges with the sable filbert. The interface between the mountains and sky may appear as a hard edge in the actual subject, but to help communicate distance, soften it just a little.

1 soften this edge just a little
2 soft edges; reduced value contrast

9 < PAINT THE LARGE PINE

Prepare for the tree by completing the landscape beyond. Now, place the tree, working wet-into-wet. Paint tree foliage with the no. 10 long bristle filbert. Holding the brush perpendicular to the painting surface, gently stomp the tree texture onto the canvas. Paint snow on the distant slope with small and medium size bristle brushes and the painting is ready for the final refinements when you continue tomorrow.

1 Viridian + Transparent Oxide Red
2 add Cadmium Yellow Deep to tree color

MUSINGS | *What the painting wants in this moment is not necessarily the same as before. Painting is dynamic and slippery. Every brushstroke changes every other stroke. Innovation requires risk. How can I know what I feel if I keep censoring myself?*

10 > MAKE COLOR ADJUSTMENTS AND ADD FINAL DETAILS

Day three. Review the five ways to create distance, stand back and evaluate how each plane of depth relates to the entire composition. Is it light or dark enough, warm or cool enough? Is the color too intense, or not bright enough? Is there enough texture, or too much? Are edges too hard or soft? Spend a few hours, or if necessary, a few days gently nudging the painting to completion. When the painting says what you want it to say, stop.

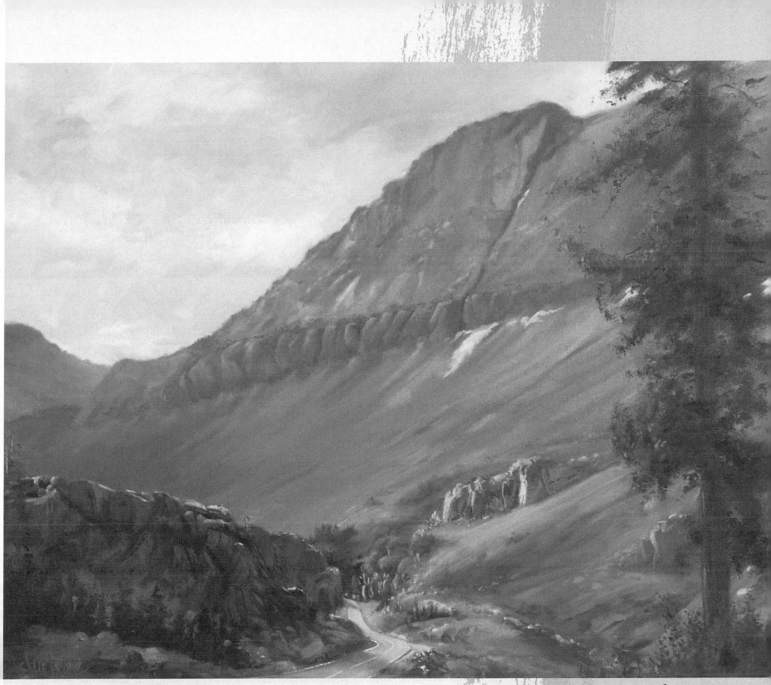

Sonora Pass
oil on canvas
24" × 30" (61cm × 76cm)

Let's Review

Linear perspective, overlapping, aerial perspective, texture and edges are the means you can employ to create a feeling of depth in your paintings. While all five of these devices may not be necessary in every painting you do, look for each of them. Use as many as you can to get your viewer into your work, even when you are painting a still life or portrait where the distance is only a few feet.

an oil sketch

Materials list

Cadmium Yellow Lemon

Cadmium Yellow Deep

Yellow Ochre Light

Transparent Oxide Red

Cadmium Scarlet
 (or Cadmium Red Light)

Terra Rosa

Ultramarine Blue Deep

Cobalt Blue Light

Viridian

Titanium White

BRUSHES

a selection of small, medium
 and large brushes (see page 14)

TOOLS

painting knife

rag

mineral spirits or turpentine

pocket mirror

Because an oil sketch can be painted in a short period of time, you can capture the light before the world turns. It is a good way to familiarize yourself with a subject in preparation for a larger, more refined painting. The better you understand your subject, the more liberties you will be able to take when painting it. The sketch demonstrated here is a variation on the basic approach explained in demonstration one (see page 62). The entire canvas is first laid in, and then three distinct areas of the composition are developed, one at a time.

You can then use the sketch as a guide for composition and color when painting the larger, more refined painting of the same subject. You might do each discrete portion of the canvas on a separate day as shown in demonstration seven (see page 104). Working each day during the same time period as the sketch, it will be easy to depict the same lighting effect you captured previously. Because most of your color and compositional problems will have been worked out in advance, you will have time to paint wet-into-wet at a more leisurely pace, rendering the subtleties of your subject with the confidence of knowing what you're doing. You've been there before.

Relax your grip and draw forms with the brush rather than filling in between the outlines of objects. Instead of painting rigid, carefully rendered boundaries between shapes, which take more time, let transitions from shape to shape occur organically. Make edges secondary to the forms they enclose. Don't hurry. Work at a pace that feels natural to you. Instead of painting rocks, water and foliage, think shapes, values and edges. Analyze color in terms of light/dark, warm/cool and bright/dull. It's okay if your work is imperfect. What is perfection anyhow? When painting an oil sketch, you're not expecting a masterpiece, it's an exploration.

1 < LOCATE THE MAIN SHAPES

After toning the painting surface to lower the value from stark white, block in the main shapes of the composition with a no. 10 flat bristle and paint thinned with turpentine or mineral spirits. Arrange the three main shapes of the sketch—the rocky shore in the lower right, the area to be occupied by the stream and the distant background plane.

1 Cobalt Blue Light + Transparent Oxide Red

2 < PAINT THE DARKEST WATER SHAPES

The composition consists of areas of water, rocks and distant background. It doesn't matter which of these areas you lay in first, second and third. The idea is to cover the canvas rapidly with broad areas of color before the light changes appreciably. Study the darker water shapes in the actual subject and lay them in with a large brush. Forget about painting "water." Just read and paint shapes of color the way you see them. You can work into and over these shapes later as needed.

1 Cobalt Blue Light + Yellow Ochre Light
2 add Viridian to previous mixed Cobalt Blue
 Light + Yellow Ochre Light
3 Transparent Oxide Red + Yellow Ochre Light
4 Viridian + Transparent Oxide Red + Cadmium
 Yellow Deep

3 < BEGIN PAINTING THE ROCK SHAPES

As you begin the first painting of rock shapes, don't try to render all of the wonderful variations of shape and color in the individual rocks. Squint your eyes and look for simplified masses of rocks grouped together. You will refine the rocks later. You now have dark, middle and light reference values with which to compare other values as you further develop the painting.

1 Yellow Ochre Light + Cadmium Yellow Deep
2 Ultramarine Blue Deep + Transparent Oxide Red

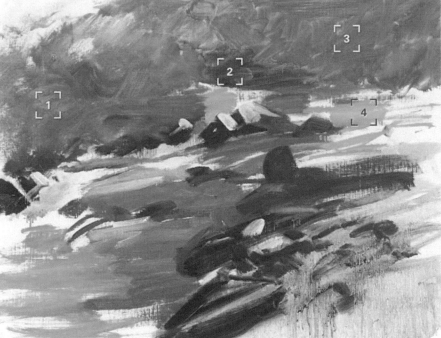

4 < BEGIN THE DISTANT PLANE

Before laying in the background, squint your eyes again and look for simplified shapes. Some areas of foliage are brilliantly lighted by the warm sun; others are in shadow, lighted by cool light from the sky. Although the distant plane is a complex maze of detail, ignore this for now and paint the values you see beneath the surface layer of foliage. Use the larger brushes to help you keep from getting lost in details. Later, you will develop foliage textures into and over the underpainting.

1 Viridian + Transparent Oxide Red + Cadmium Yellow Deep
2 Transparent Oxide Red + Cobalt Blue Light
3 Cobalt Blue Light + Yellow Ochre Light + Viridian
4 Cadmium Yellow Lemon + Viridian

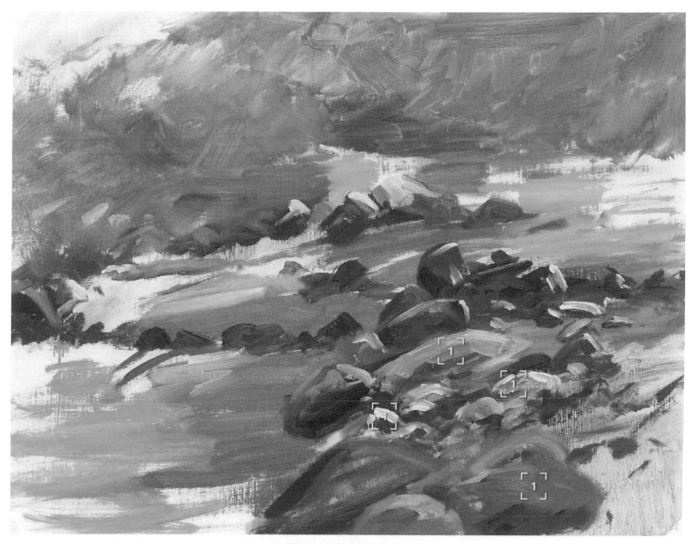

5 ∧ DEVELOP INDIVIDUAL ROCKS

Now that the canvas is covered, bring your attention forward to the rocks and water. These are the more important parts of the painting. You don't have to replicate every rock you see. But do strive for a variety of sizes and shapes. Paint a group of rocks first as a single shape, and then work lighter variations of color over this for individual rocks. Use brushes that are a little larger than you're comfortable with to help you keep from nit-picking details. In places that are lit by the sun, use a heavier paint application with brushstrokes that follow the forms of the rocks.

1 various combinations of Cadmium Yellow Deep, Cadmium Scarlet, Cobalt Blue Light, Transparent Oxide Red, Terra Rosa

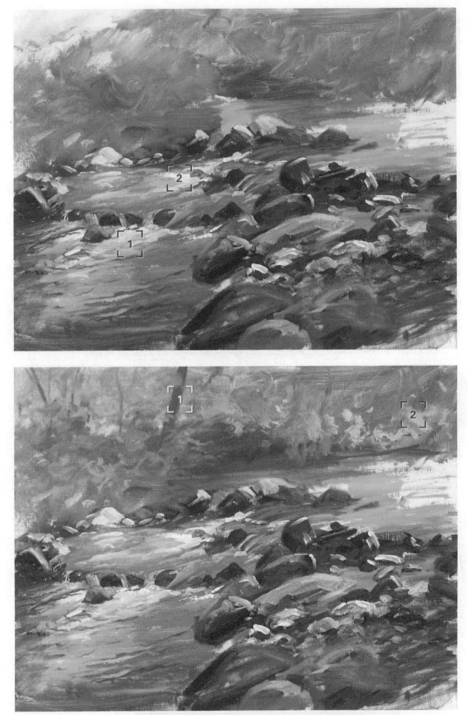

6 < REFINE THE WATER

Moving water is a subject unto itself. Paint broad, overall shapes first, then ripples and reflections, and add the foam last. What color is water? Look at the your subject! For this sketch, much of the water is the color of what it reflects. Analyze the hue, value and intensity of various areas of the water. Compare them to each other and to other parts of the painting. Having blocked in the large areas of water, paint the skin next—the ripples and reflections. Look for recurring patterns in the constantly moving surface. Before painting the foam, look carefully for cool and warm variations from shadow to light.

1 white + Cobalt Blue Light
2 white + Cadmium Yellow Deep

7 < DEVELOP THE DISTANT PLANE

Use loose, ragged strokes with a variety of brushes to indicate foliage in the plane beyond the water. It is unnecessary to refine the foliage beyond a suggestion of texture because it is more distant and less important than the water and rocks. Stand back and study your progress backwards in a pocket mirror to discern whether the painting needs anything more. In fact, there are five dark rocks leading like a row of dominos, straight up the middle of the painting. This unnatural, machinelike spacing will need to be repaired.

1 Cobalt Blue Light + Transparent Oxide Red
2 Cadmium Yellow Lemon + Viridian

8 > MAKE FINAL ADJUSTMENTS

Scrape out a couple of rocks with the painting knife and repaint the water to improve your composition. Study the painting some more. Does the composition pull to the left or right? If so, adjust value contrasts and/or edges to bring it into balance. Help the middle-distance rocks recede a little more by making the light-struck parts cooler. In a short period of time (this one took about two hours) you have created a lively, colorful study, so don't overwork it. Stop painting.

Untitled Color Study
oil on hardboard panel
16" × 20" (41cm × 51cm)

Let's Review

Oil sketches are often more expressive than carefully refined work. They are a good way to experiment with various painting approaches without investing an inordinate amount of time. They help you to rapidly develop your understanding of the painting process. Use your best oil sketches as preliminary planning for larger, more carefully developed work.

painting a large canvas

I have painted this subject a number of times under different weather conditions and the changing of seasons, each time with renewed commitment to capture its magnificence. It continues to be challenging, so I keep going back for more. Although some of my efforts have been more successful than others, each one has been a learning experience. One day I'll create the masterpiece.

The more times you draw and paint a particular subject, the more familiar with it you become. When you have solved most of the procedural problems, you are freed up to interpret the subject artistically. In the previous demonstration, three main areas of the painting were developed concurrently. This was possible because the smaller size of the canvas made it easy to complete the work in a few hours while the paint remained wet. In this final demonstration, the larger size of the canvas (24" x 48" [61cm x 122cm]) will require a more studied approach. There are four main parts to the composition; each of the four areas will be painted individually. With such a large canvas, attempting to develop the intricacies of the subject all at once would result in dried paint before the work could be completed. This wouldn't be "wrong," but it could limit the paint-handling possibilities available when working wet-into-wet.

No matter how well you know a landscape subject, take time to reconnect with it before beginning a new painting. Each day is different, and every day you are different. Notice the quality of atmosphere. Think about how the light is likely to change over time. What will you paint first, second, and so on? Plan your approach and try to stick with your plan. At the same time, stay flexible and allow the painting to grow in its own way. You cannot know what the painting will look like until it is well along. Stay with your plan and work through periods of chaos.

Your painting process is a combination of thinking and feeling. Balance knowledge with intuition. While focusing on learning, you may place greater emphasis on the technical side of painting, but don't simply mimic how a subject looks. Try to communicate the feeling you have for it. That's art. Take breaks often and watch out for fatigue; when you are tired you may paint without thinking. Think, feel, and balance the two.

Materials list

PIGMENTS

Cadmium Yellow Lemon

Cadmium Yellow Deep

Transparent Oxide Red

Cadmium Scarlet

Terra Rosa

Ultramarine Blue Deep

Cobalt Blue Light

Prussian Blue

Viridian

Titanium White

BRUSHES

a selection of small, medium
and large brushes (see page 14)

TOOLS

painting knife

rag

mineral spirits or turpentine

pocket mirror

1 < DON'T NEGLECT PRELIMINARY WORK

The color study shown below is 12" × 24" (30cm × 61cm). Your preliminary studies will often have a spontaneous quality that is more difficult to achieve in larger work. Use the studies to learn as much as you can about the subject.

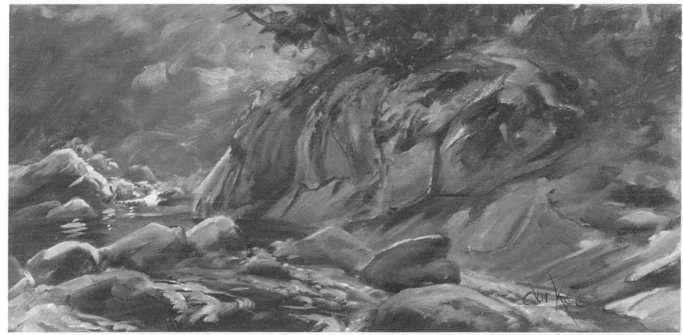

2 < THINK COMPOSITION FIRST

Begin with a few lines to locate the main shapes, and then block in the shapes with thin paint using a no. 12 flat bristle. Avoid heavy buildup of pigment at this stage. The largest shape is a rock ledge with many subdivisions of shapes. Ignore most of these smaller shapes for now and think of the entire ledge as one large mass. The empty space in the upper left of the canvas is a negative shape, but a shape nevertheless and is therefore part of the composition. Work out a pleasing variety of main shapes. Take your time. A good beginning will save much anguish later on.

1 Cobalt Blue Light + Transparent Oxide Red

3 < ESTABLISH THE VALUE PATTERN

Feeling your way into the composition, brush the paint onto the canvas thinly, retaining the texture of the canvas. Thin the paint with turpentine or mineral spirits. The thinner will evaporate fairly quickly, and this first layer of paint will be easy to build over and into with subsequent layers of pigment. At this stage the color combinations needn't be pinpoint accurate, but do look for how one area relates to another—this shape is warmer, that one is cooler, more green here, more blue there.

1 mix orange from Cadmium Yellow Deep + Cadmium Scarlet and then add to Prussian Blue
2 Viridian + Transparent Oxide Red
3 Viridian + Ultramarine Blue Deep

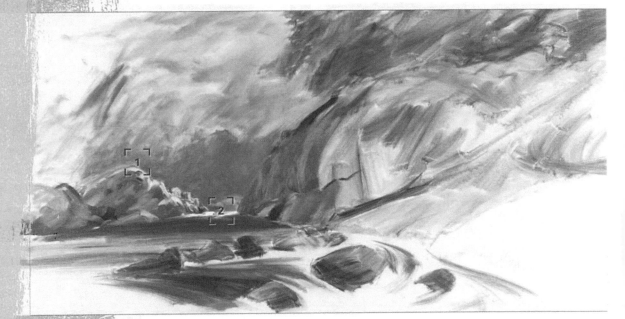

4 ∧ NAIL DOWN THE CENTER OF INTEREST

Bring the area around the sunlit rocks and distant water to near completion. This is the focal area. Now, stand back and view the canvas backwards in a pocket mirror. You should be able to feel a thrust toward the focal area even at this early stage. From here on, every other part of the painting will be of less importance than the focal area, yet lead to it or in some way support its primacy.

1 Cadmium Yellow Deep + Cadmium Scarlet + white
2 white + Cadmium Yellow Deep

MUSINGS | *Establish what is important to your picture idea; get it onto the canvas right away. Then paint the rest of the painting to support it and make it even more significant. Make everything else less important by reducing value contrasts and intensity of colors, and softening edges in peripheral areas.*

5 ∧ LAY IN THE ROCK LEDGE

Remember, painting is drawing with a brush. As described in chapter two, think shapes, values and edges. Subdivide the large shape of the rock ledge into three or four smaller shapes, then divide these into smaller ones yet. Do not use too much paint. Thin layers are easier to control and allow you to build up the painting surface a little at a time, resulting in a greater variety of color and texture. Save the thicker brush or knife strokes for later.

1 Cobalt Blue Light + Terra Rosa and/or Transparent Oxide Red

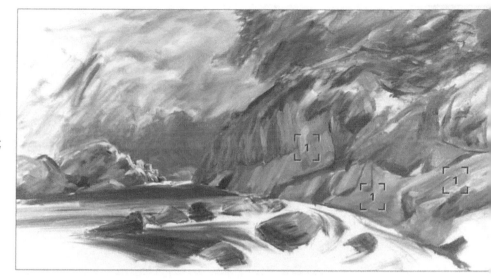

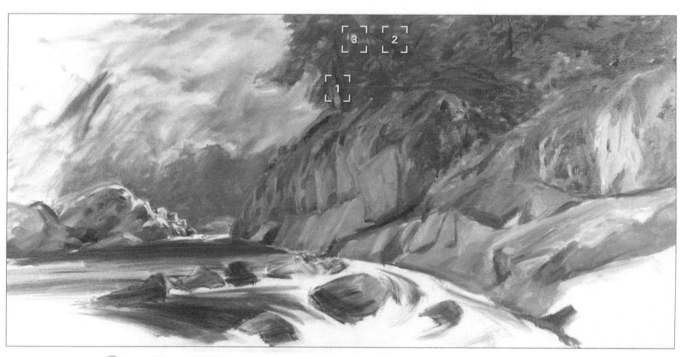

6 ∧ CONTINUE DEVELOPING THE ROCK LEDGE AND TREES

As a general principle, values become lighter with distance. However, in this case, the ledge is darker on the distant end and lighter at the near end because of the influence of reflected light. Never paint by formula. If there is a difference between your understanding of general principles and what you actually see, paint what you see. Squint your eyes to compare one value with another. Don't nitpick the small details of the rocks and trees above. Just get the shapes and beginning textures, then move on.

1 Ultramarine Blue Deep + Transparent Oxide Red
2 Viridian + Transparent Oxide Red
3 add Cadmium Yellow Deep to previously mixed Viridian + Transparent Oxide Red

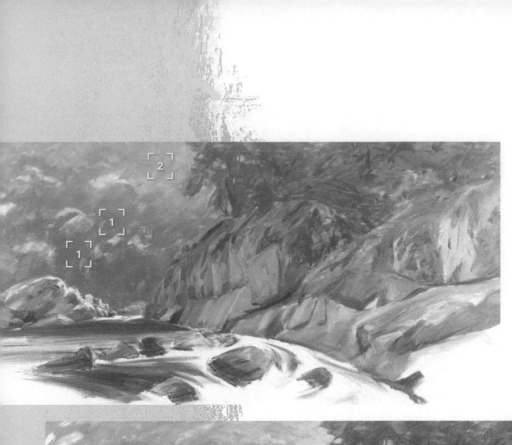

7 < BEGIN THE DISTANT PLANE

Ignoring the light-struck parts of the distant hillside, lay in the shadow values you see there with a no. 10 flat bristle brush. The cool atmosphere makes the upper, more distant part of the hill lighter and cooler.

1. mix orange from Cadmium Yellow Deep + Cadmium Scarlet and then add to Prussian Blue to make green
2. add Cobalt Blue Light + white to previously mixed green

8 ∧ CONTINUE DEVELOPING THE DISTANT PLANE

Now, paint the sunlit parts of the distant trees. Although these cool greens are fairly intense in sunlight, use care that their values don't steal attention from the sunlit rocks and water in the center of interest just below.

1. Cadmium Yellow Lemon + Ultramarine Blue Deep
2. add Cobalt Blue Light + white to previously mixed Cadmium Lemon + Ultramarine Blue Deep

MUSINGS | *The light is changing fast. My painting is only two-thirds complete. I am tired. Do the next thing, and the next. And then the next. I have lost more paintings from panic than from fatigue.*

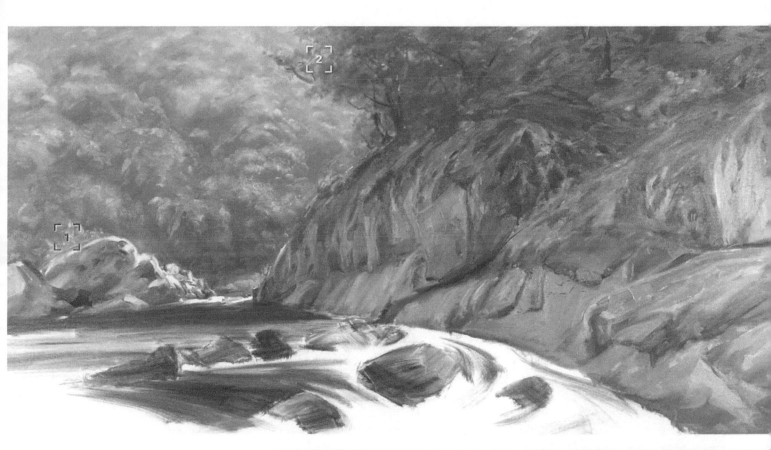

9 ∧ UNIFY THE ROCK LEDGE WITH THE DISTANT PLANE

Study the interface where the distant plane in the upper left slides behind the rock ledge and the large tree on the right. Refine this interface while the paint is still wet. At this distance it is not necessary to paint every small detail you see. Look for hard and soft edges, warmer and cooler colors, lighter and darker values. Work back and forth between the two planes, but don't oversoften edges unless that's how you actually see them.

1 Cadmium Yellow Lemon + Viridian
2 Cadmium Yellow Deep + Viridian

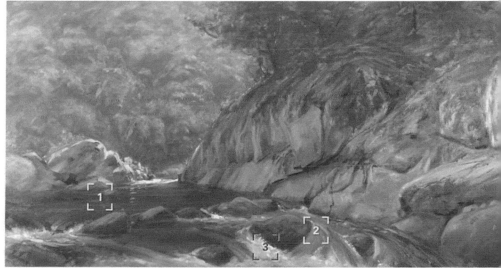

10 ∧ PAINT THE WATER

Paint the water in the same manner as demonstrations five (see page 88) and eight (see page 110)—dark shapes first, then ripples and reflections, adding the foam last. Use values for the foam in shadow that are a few steps darker than in the distance where the water is lit by the sun.

Now ask, "What does the painting want?" The rock ledge needs more reflected light on the upper rounded surface to give it more form, and the trees on top could be darker to contrast with the distant plane. The distant plane is too drab and needs more of a feeling of light (i.e. lighter and a little warmer).

1 Viridian + Transparent Oxide Red + Cadmium Yellow Deep
2 Viridian + Ultramarine Blue Deep + white
3 add more white to previously mixed Viridian + Ultramarine Blue Deep

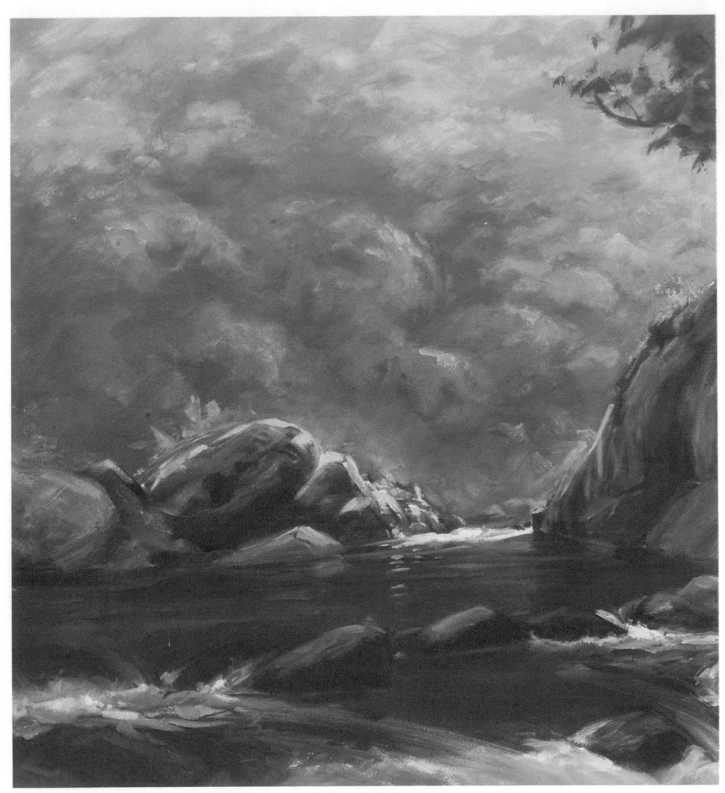

11 ∧ PULL THE PAINTING TOGETHER

Referring back to the preliminary study, think of the idea you want the whole painting to communicate. Analyze the needs of the composition and make the changes needed. Depending on your intention, you can spend another hour or several days perfecting your work. In the final analysis, I have chosen to simplify parts of this painting rather than further develop them. Your personal taste may lead you to refine these areas instead.

Let's Review

When you are familiar with a subject, you can more easily coordinate disparate parts of a large

canvas, working wet-into-wet as you paint them one at a time. Before beginning a painting, plan

your approach according to the needs of the project you have in mind and the feeling you want

the painting to project. A large painting is a lot more work and can be exponentially more dif-

ficult. I recommend that you paint small until you have built up a history of experience.

Big Rock
oil on canvas
24" × 48" (61cm × 122cm)

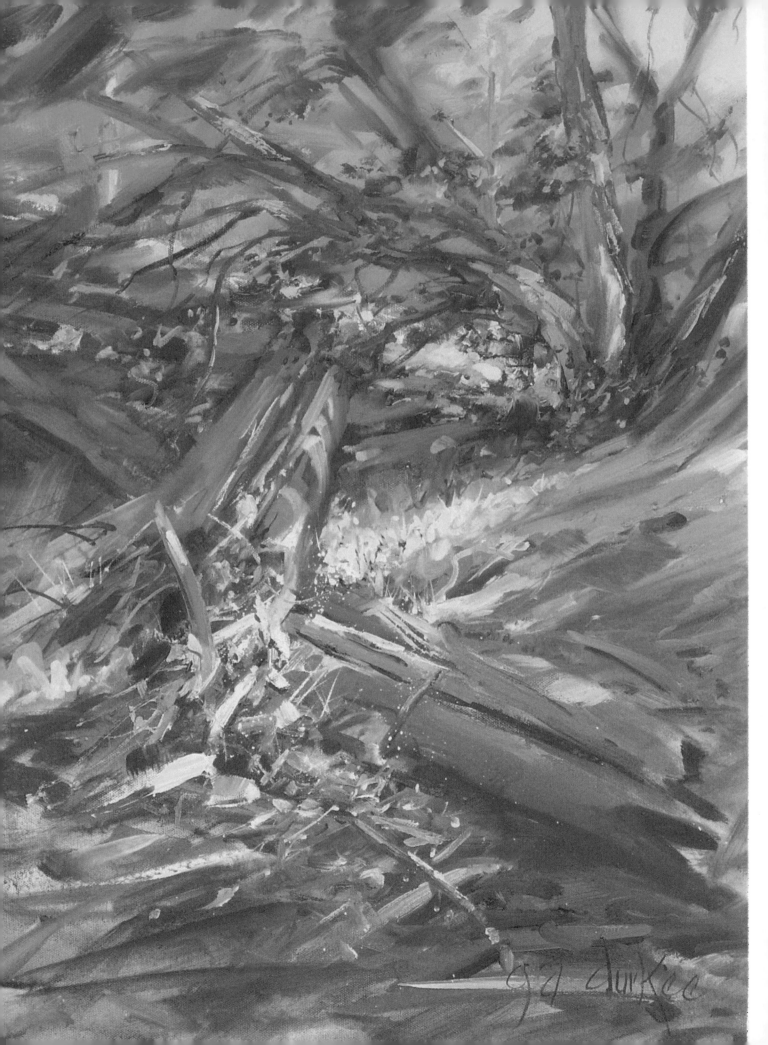

Conclusion: Cultivate the Art Spirit

How challenging it is to be fully present—to sustain the dreamlike space where inspired work can take place. Every artist knows this state. To attempt to describe it, however, is to try to put it in a box, as though it could be saved and used again later. What takes the lid off your creativity cannot be grasped and held with words, but is freely given in the act of painting. Each work of art is an eternity that has been captured in moments of being fully engaged.

Open wide to the painting experience. Allow trees, rocks, water, artist's pigments and the love of being alive to commingle on your canvas. At day's end, after washing brushes and folding your battered and paint-splattered easel, you will be exactly where you need to be. Whether your painting is masterful or has fallen short of your vision, you are an artist doing what artists do. Trust the process. Keep learning, and always paint from your heart.

george allen durkee

*"Where the spirit
does not work with the hand,
there is no art."*

— Leonardo da Vinci

Dead Wood oil on canvas | 24" × 18" (61cm × 46cm)

index

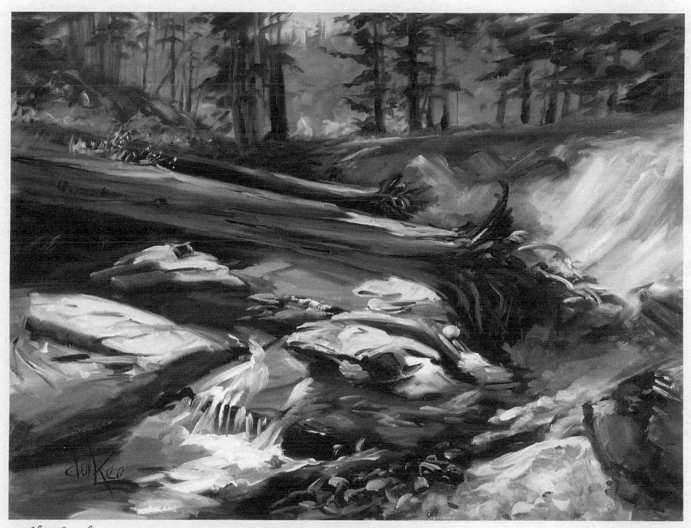

Walker Creek #2 oil on canvas | 24" × 30" (61cm × 76cm)

The best in fine art instruction is from
North Light Books

Made in the USA
Lexington, KY
07 May 2014